POSTCARD HISTORY SERIES

New Castle
and Mahoningtown

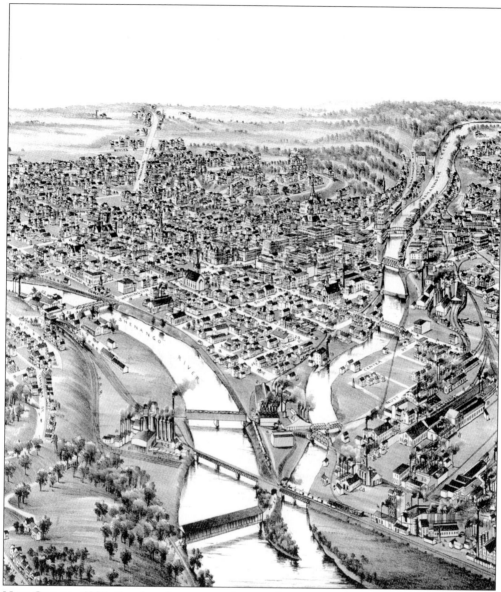

NEW CASTLE, 1896. Seen here is a panoramic map of New Castle showing the Shenango River and Neshannock Creek. (Courtesy of Lawrence County Historical Society.)

On the front cover: **BUSINESS CENTER OF MAHONINGTOWN IN THE EARLY 1900s.** North Liberty Street was where the residents of Mahoningtown could find the post office, a barber, two drugstores, clothing stores, a movie theater, and a pool hall. Nearby were the fire company, the grade school, and several churches. Here the streetcar is headed to the railroad station at the end of the line.

On the back cover: **BOAT RACE ON CASCADE PARK LAKE.** Summer excursions to Cascade Park were popular with New Castle residents as well as with groups visiting from Pittsburgh and other communities. Streetcars ran frequently, dropping passengers close to Cascade Lake, which offered swimming, boat rides, and, pictured here, boat races.

POSTCARD HISTORY SERIES

New Castle and Mahoningtown

Anita DeVivo

ARCADIA

Published by Arcadia Publishing
Charleston SC, Chicago IL, Portsmouth NH, San Francisco CA

Printed in the United States of America

Library of Congress Catalog Card Number: 2005936972

For all general information contact Arcadia Publishing at:
Telephone 843-853-2070
Fax 843-853-0044
E-mail sales@arcadiapublishing.com
For customer service and orders:
Toll-Free 1-888-313-2665

Visit us on the Internet at http://www.arcadiapublishing.com

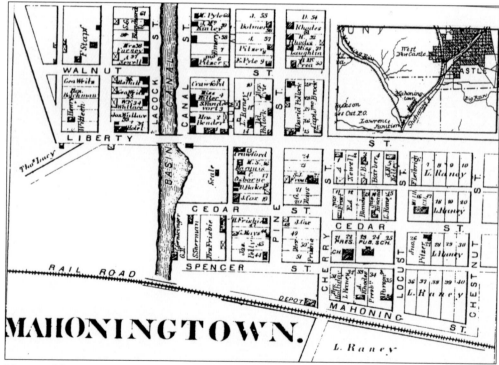

MAP OF MAHONINGTOWN, 1860s. Business in Mahoningtown increased at a rapid rate after the Cross-Cut Canal was built. Around 1871, the canal was replaced by the railroads that were built along the canal beds. The inset shows Mahoningtown south of New Castle.

CONTENTS

ACKNOWLEDGMENTS

A special thank you to Jane Santini, who was so patient, helpful, and enthusiastic while I sorted through postcards, photographs, directories, and documents on our antiquing trips; and Adam Pivovar, who showed me parts of New Castle I had never seen, provided maps and photographs, and gave me facts that could not be found in books.

Thanks also to Philomena Jurey, Adam Pivovar, Bob Presnar, Jane Santini, Lynn Slovonsky, Joan Whitman, and Beverly Zona who read through the manuscript; David Izzo who trusted me with his rare Mahoningtown postcards; also to Michael Colella, Ann Lukas, Larry Parisi, and Jane Santini for letting me borrow their valuable cards; Beverly Zona, Chris Fabian, and Kate Minteer for research assistance in the History Room of the New Castle Public Library; Bob Presnar for research assistance at the Lawrence County Historical Society; Will Rotunno, Don Barnes, Wayne Cole, Ed and Sally Daytner, John Makar, Charles Norris, and Andy and Nikki Piccuta for information and general support; and all the photograph contributors whose names appear under their photographs.

INTRODUCTION

Two waterways start the story of New Castle. They are the Shenango River and the Neshannock Creek.

In 1798, a grant of 50 acres of wilderness was given to John Carlysle Stewart. Stewart, a surveyor, named the new territory for his hometown, New Castle, Delaware. He established the Shenango River as the western boundary, and the Neshannock Creek as the southern boundary. With Apple Alley to the east and Falls Street to the north, a person could walk around the periphery of the new community in 20 minutes.

In the first years of the new town, ferries were the only way to cross the Shenango and the Neshannock. By 1825, bridges had been built across the two waterways. When the Beaver Division of the Erie Canal Extension opened in 1833, the canals ran in and out of the two waterways and used their shores as loading platforms.

Two and a half miles south of New Castle was another tract of land, Mahoningtown, with 500 acres and its own two waterways: the Shenango River from the north, and the Mahoning River from the northwest. The town was laid out in 1836. Two years later, the Cross-Cut Canal was opened there. The Cross-Cut extended the services of the Erie Canal westward to Akron and Cleveland. It also linked the commerce of Mahoningtown and New Castle.

The two communities were much alike. Although New Castle was larger, with 6,000 residents in the 1860s, Mahoningtown's population of 600 or 700 was a strong community. Both towns had their main streets with thriving businesses, churches, schools, local governments, and young industries including flour mills, lumber yards, and, eventually, in the 1860s, the railroads.

In 1871, the canals were abandoned for rail transportation. The railroads became what was probably the single largest source of social change in New Castle and Mahoningtown. Faster and more efficient transportation led to the burgeoning of the tin, iron, and steel mills, coal and limestone mining, cement manufacture, potteries, glass factories, and countless small businesses to support the economic growth of the two towns.

All of these industries, railroads included, needed workers. And the workers came. By 1900, New Castle's population of nearly 12,000 had exploded. There were now 28,000 residents.

Where did all these people come from? By that time, German and Irish immigrants were already established among the Scotch-Irish in New Castle. The Welsh and the English were arriving. Then the Italians reached New Castle in great numbers, most of them settling in Mahoningtown and on the south side of New Castle. The first Polish immigrants settled in New Castle's Oakland district and then on Sheep Hill. The Slovaks, too, settled on Sheep Hill. Then came Czechs, Croatians, Ukrainians, and Russians.

There was plenty of work for everybody. Two thousand were employed at the tin mill, another 2,000 at Carnegie Steel, and thousands more in the other mills and factories and on the railroads. The introduction of streetcars on New Castle's streets in 1890 had hastened the prosperous years. Workers could get to their jobs, shoppers could get to the stores, and children could get to the parks.

At this time, three railroads ran through Mahoningtown, and most of the men in the town were railroaders. Somebody in New Castle noticed that the thriving community of Mahoningtown was collecting increasing amounts of taxes and yet did not have streetcar service. In the mid-1890s, the City of New Castle offered to provide electric streetcar service if Mahoningtown would agree to be annexed to New Castle as its seventh ward. In 1896, the Mahoningtown Street Railway was chartered, and on January 12, 1898, the annexation took place. Mahoningtown was no more.

A few months later, New Castle's street-naming committee revised the names of 24 streets throughout the city. It was as though they needed to put their stamp on the new seventh ward because almost half of the names changed were in Mahoningtown. (The map on page 4 of this book was drawn before the committee took action.) Streets named for trees (Chestnut, Spruce, and Locust) were changed to names of historic men (Madison, Clayton, and Lafayette). For some reason, Cherry and Cedar Streets remained unchanged.

Mahoningtown did not quite disappear as expected. The train conductors still announced "Mahoningtown" for passengers headed to New Castle. The post office was called the Mahoningtown Station for many years, and mail addressed to Mahoningtown continued to be delivered there. And as can be seen in this book, postcard publishers continued to send their photographers there.

As it turned out, New Castle was wise to add Mahoningtown's taxes to the city coffers . A gradual economic decline began after the sale of the tin, iron, and steel plants to U.S. Steel in 1898. Between labor union difficulties and the diversion of investment capital from New Castle, it became apparent that "absentee landlords" did not have New Castle's interests at heart. The city enjoyed two bursts of prosperity with World War I and World War II, but the depression between the wars took its toll.

In the years following World War II, New Castle's future leaders, already exposed to a wider world through military service, had access to education through the G.I. Bill. Many of them had more and better work opportunities that took them out of town. Although in 1950, when the city's population was at its peak—51,000—the number of residents began to dwindle. Today, the population is around 25,000.

Various efforts to revive New Castle's economy have been made. In the 1970s, the New Castle Redevelopment Authority made big plans for the city but somehow got sidetracked. In the process, many of the buildings that went up in New Castle's heyday disappeared. Today, there are the Economic Development Authority; a large-scale plan for a downtown theme park; negotiations for an industrial park on the outskirts of the city; and a downtown revitalization program that has aimed to transform the main street with new lampposts, modern parking meters, and hanging plants.

Is the future of New Castle a matter of "all dressed up with no place to go," or is it "if you build it, they will come?" Time will tell.

In the meantime, the Neshannock Creek and the Shenango and Mahoning Rivers are still there, and the city's heritage hangs in the balance. These are what make the postcard images in this book so precious. The pictures are like little works of art that tickle the imagination. Or they are records of the past that preserve a moment in time. Either way, they enable us, for a brief moment, to live in a time when it was possible for a crowd of 70,000 to pour into New Castle to celebrate the Fourth of July (see page 90).

One

DOWNTOWN AND UPTOWN

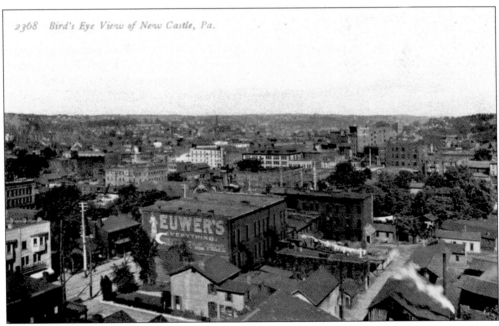

DOWNTOWN, EARLY 1900S. This bird's-eye view of downtown New Castle looks southwest from the Lawrence County Courthouse. The steeple on the horizon (center) marks the Diamond. The tall building at right center is the Lawrence Savings and Trust Building. The Euwer's sign is advertising the department store near Mill Street.

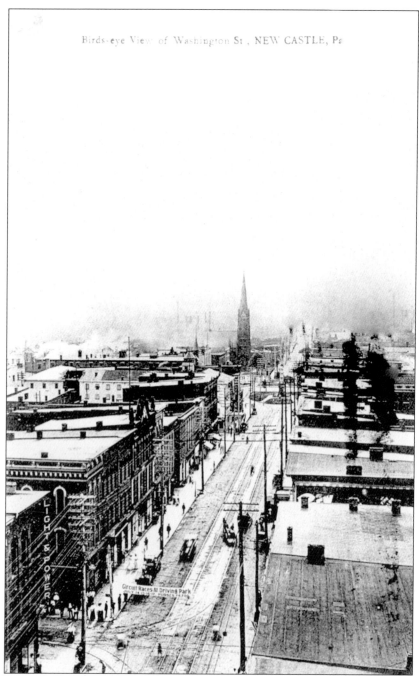

Birds-eye View of Washington St., NEW CASTLE, Pa.

WASHINGTON STREET, EARLY 1900S. East Washington Street, between the Shenango River and Neshannock Creek, is "downtown" to those who live on the North Hill and the West Side. For those who live on the South Side or in Mahoningtown, it is "uptown." This postcard, published by druggists Love and Megown and printed in France, is postmarked 1912. It shows the New Castle Electric Company on the corner of Mill Street (lower left). The First Christian Church is on the Diamond (center). Shopping in town must have been good—most of the pedestrians appear to be women. The banner overhead reads "Circuit Races at Driving Park."

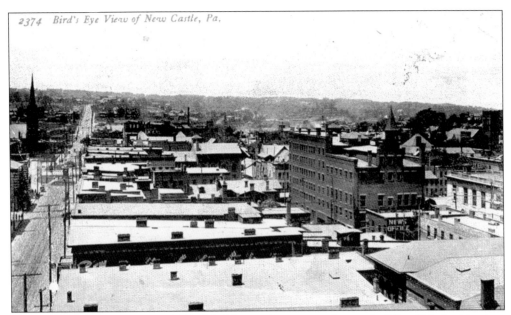

DOWNTOWN AERIAL VIEW, 1911. Washington Street stretches to the West Side in this view. The corner of Mercer and Washington Streets is at the lower left. The white building on the right is the post office (later the public library). The steeple of the First Methodist Church is right center and the big brick building is the Greer Building. The New Castle News office is close to the Greer Building on Apple Alley.

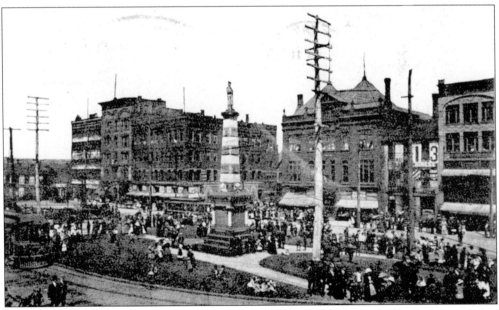

DEDICATION OF SOLDIER'S MONUMENT, 1896. In the early 1890s, the Ladies Park Association raised money for a monument to honor soldiers who died in the Civil War. The granite memorial was dedicated in 1896. Charles Andrews posed for the statue, which was carved by John Hart, a local monument maker. The statue faces east at parade rest. This view of the dedication shows the YMCA building behind the telegraph pole. The building at the right is still standing.

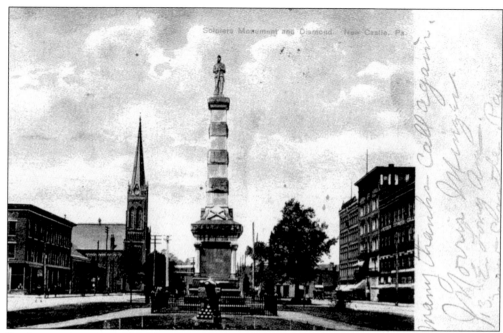

LOOKING WEST ON THE DIAMOND, 1909. Looking west, the Soldier's Monument, the cannon, and the First Christian Church were familiar landmarks on the public square in 1909, as they are today. The buildings on the left, Horton and McNabb Hardware, Fisher and Wengle Coalyard, and Suber Grocery, were eventually replaced by the post office building. The Hileman, Hoyt, and Wallace Blocks are to the right.

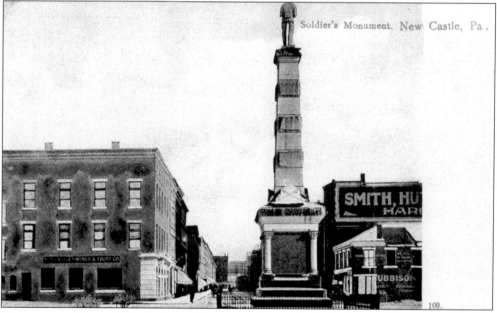

MONUMENT VIEW, 1907. Cochran Way crosses immediately in front of the monument as it looks down East Washington Street toward Mercer Street. On the left is the New Castle Savings and Trust Company. On the right is the Western Union office. Next to it is Smith and Hutton Hardware. Both of these buildings are still standing.

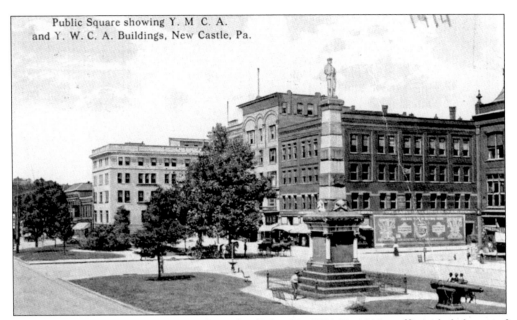

Public Square showing Y. M. C. A. and Y. W. C. A. Buildings, New Castle, Pa.

THE DIAMOND, 1914. The Diamond was first lighted in 1856. By 1914, traffic included users of the YMCA and the YWCA. The building at the right was given to the YMCA in 1885 by New Castle evangelist and composer of hymns, Ira Sankey. When a new building for the YMCA was completed in 1911 (left), the YWCA, founded in 1907, moved into the YMCA's old building.

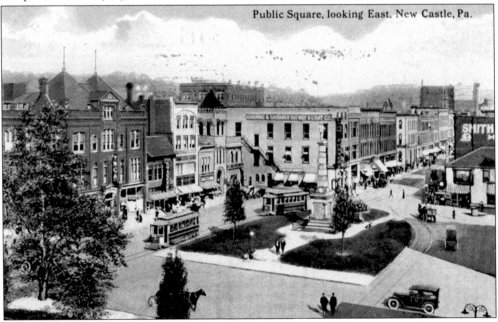

Public Square, looking East, New Castle, Pa.

THE DIAMOND, 1916. This view of the north and east sides of the Diamond shows the Central United Presbyterian Church (center), which burned down in 1949. The New Castle Savings and Trust Company was replaced by the Mahoning and Shenango Railway and Light Company. The Lawrence Savings and Trust Company is the tall building in the distance. Note the Victorian-style lamppost in the bottom right corner, a style that disappeared over the years, but was recently reintroduced in today's downtown.

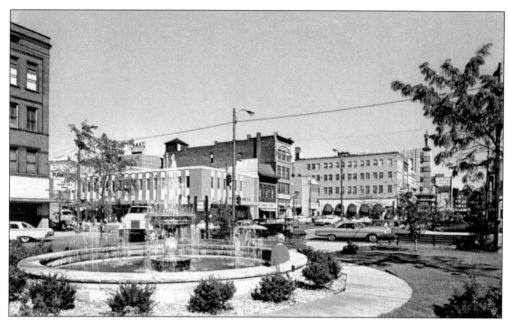

THE DIAMOND, 1980. This is a modern view of the north and east sides of the Diamond. The building in the center housed the Penn Power Company and is now vacant. The Diamond has had many names since 1798 when John Carlysle Stewart laid out the plan for New Castle: Public Square, Central Square, Market Square, Pershing Square, and most recently, Kennedy Square. The Diamond is its most common name.

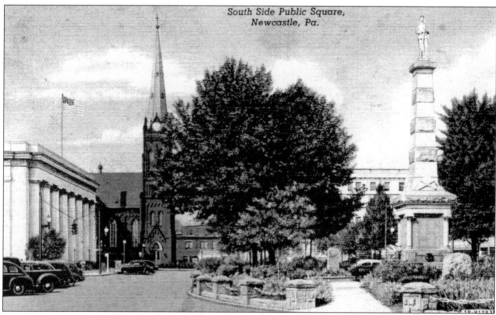

THE DIAMOND, LATE 1930s. Looking west in the 1930s, the Diamond had stone pillars connected by massive chains. The stonework, built by the Works Project Administration (WPA), is similar to walls the WPA built on Croton and Neshannock Avenues. The flowers and shrubbery are examples of how the Diamond's landscaping changed over time. In 2005, trees were removed and the gray stone pillars and original chains were replaced.

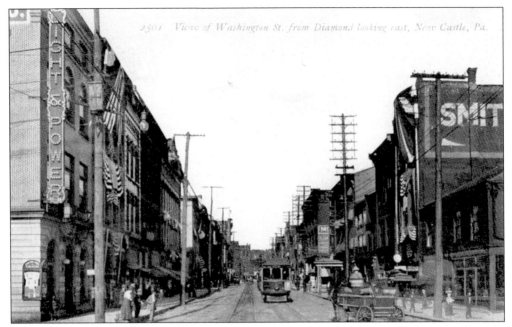

EAST WASHINGTON STREET, 1912. Looking east, a streetcar and a horse-drawn wagon share the street. The Leslie Hotel is to the right of the streetcar. The hotel, built in 1854, was a landmark until it burned down in the late 1960s. The property is now a parking lot. The advertisement on the wall at the lower left is for Cascade Park Theater, the popular outdoor theater in the park.

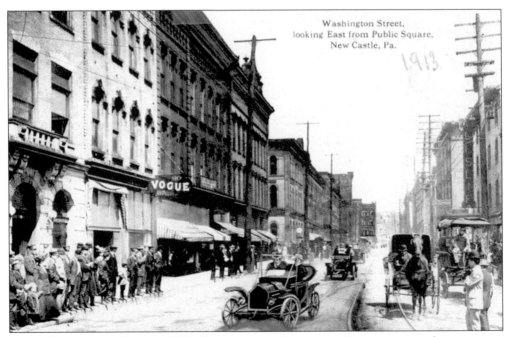

EAST WASHINGTON STREET, 1913. Looking east, this postcard shows a caravan of open touring cars passing the horse-drawn carriages as bystanders look on. Henry Ford's Model T automobiles first appeared in 1908, and by 1913, the cars were being mass-produced. The flivvers, or tin lizzies, were about to change life on New Castle's streets.

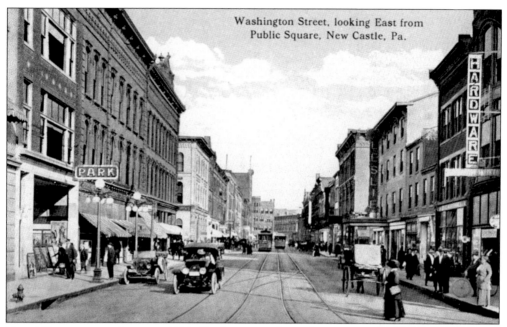

Washington Street, looking East from Public Square, New Castle, Pa.

EAST WASHINGTON STREET, 1922. By the 1920s, the Leslie Hotel and Kirk Hutton (formerly Smith, Hutton and Kirk) Hardware were still there. The Park Theater is now on the scene, and People's Bank has opened. Even though this postcard publisher has removed the telegraph poles and wires from the scene, New Castle's main street is looking prosperous.

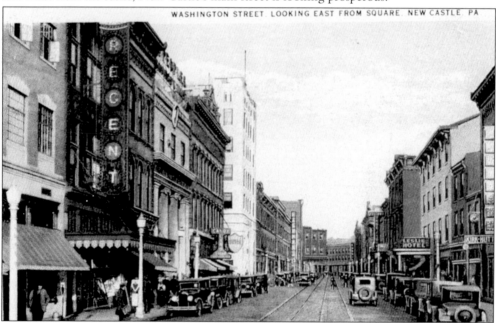

WASHINGTON STREET. LOOKING EAST FROM SQUARE. NEW CASTLE. PA.

EAST WASHINGTON STREET, LATE 1920s. By the time this postcard was published, the Park Theater was gone, replaced by the Regent Theater with a marquee. Next door, the People's Bank Building has added a large sign to its roof. On the corner of Mercer Street, the First National Bank has been built, replacing the National Bank of Lawrence County. Note the solid line of cars now parked along the street.

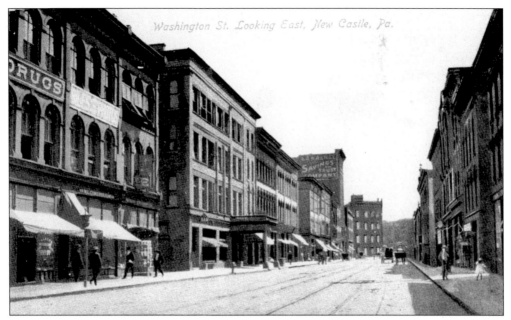

EAST WASHINGTON STREET, 1910. Looking east from North Mercer Street, on the left are the J. C. Wallace Drug Store, Biles Photography, and the Blue Ribbon Shop. Past Apple Alley, the building with the portico is the St. Cloud Hotel. Farther down is the Lawrence Savings and Trust Building, and in the distance the Pearson Building. In addition to removing the telegraph poles and wires, this postcard publisher also removed the streetlights.

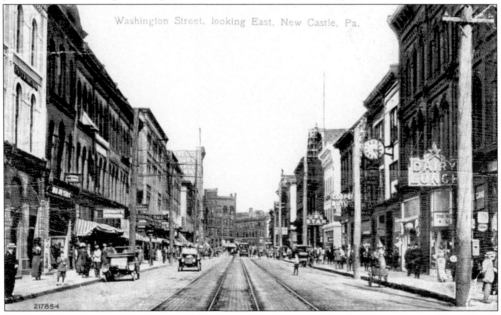

EAST WASHINGTON STREET, c. 1913. From this corner of North Mercer Street, New Castle looks prosperous. Some businesses on the right are the Sugar Bowl, Cooper and Butler, and the Star Theater. On the left are the Majestic Theater and Anthony Photographers. The reverse side of this postcard advertises the Brown and Hamilton Company, a dry goods store on the south side of Washington Street between Mill and Water Streets.

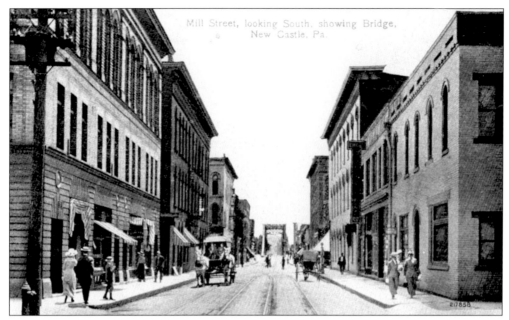

NORTH MILL STREET, C. 1907. This postcard shows the tranquility of a summer day in New Castle's business center. Looking toward Washington Street between Mill and North Streets, on the left of this block were the Wells Fargo Company, a pharmacy, a furniture store, and a market. On the right were Brindle Printing, New Castle Auto Sales, and New Castle Art Company. Out of sight beyond the bridge is Rosena Furnace.

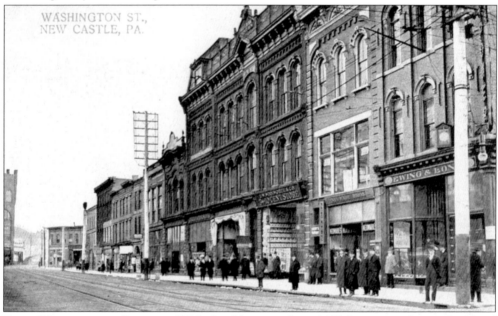

EAST WASHINGTON STREET, 1909. Looking east from Mill Street, on the south side of Washington Street are Ewing and Bond Boots and Shoes at the corner, where the Light and Power Company had been, then Neuwahl's, Woolworth's 5 and 10 Cent Store, and Euwer's Dry Goods. Over time, this corner housed many businesses, such as Jack Gerson Jewelers and Neisner Brothers. It is currently being rebuilt as a complex for shops, restaurants, and entertainment.

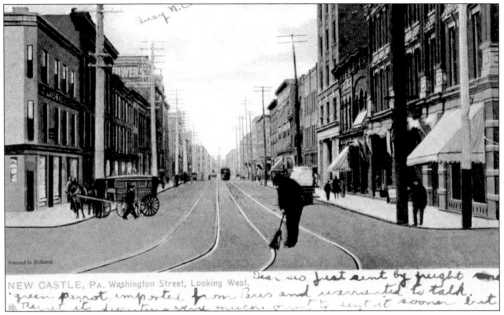

NEW CASTLE, PA. Washington Street, Looking West.

Dear sis Just sent by freight green parrot, imported from Paris and warranted to talk. Regret its departure very much. Meant to sent it sooner but

EAST WASHINGTON STREET, 1906. This view looks west from East Street. At the extreme right is the city hall. The tall building several doors down is the Lawrence Savings and Trust Building. To the left are the Dollar Savings Bank, Brown and Hamilton, and Euwer's. The sender of this card writes to her sister in Milwaukee, "Just sent by freight one green parrot imported from Paris and warranted to talk. Regret its departure very much."

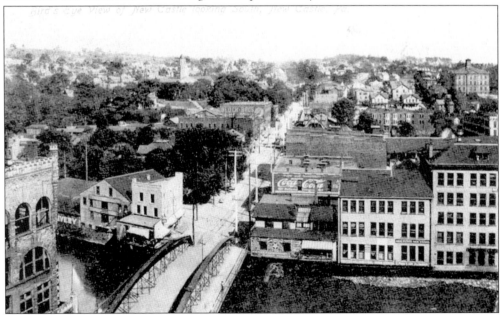

LOWER EAST SIDE, 1911. Near East Street and Washington Street was the old iron bridge, built in 1858. Crossing the Neshannock Creek, it linked New Castle's center of business to Croton Avenue and the East Side. The buildings at left center eventually were replaced by New Castle Dry Goods Company, and later Troutman's. The buildings at right center have become a park. In the distance are the county courthouse (left) and Aiken School on Pearson Street (right).

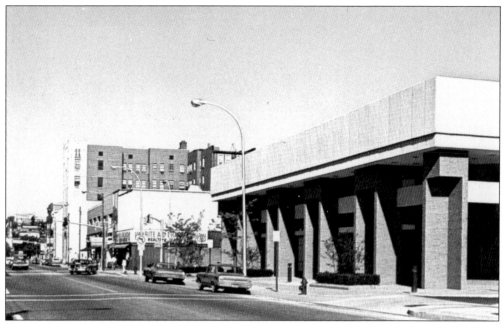

EAST WASHINGTON STREET, 1980. This postcard view looks west toward Mill Street. In 1972, the New Castle Redevelopment Authority started replacing the buildings between North Mill and East Streets with this structure called Washington Centre. It provides space to banks and a number of small businesses, as well as a spacious parking lot for its patrons.

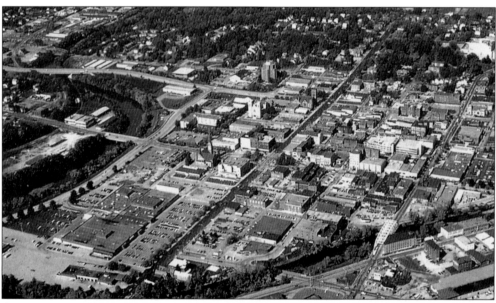

AERIAL VIEW, 1980s. Two waterways define New Castle's downtown: the Shenango River on the left, and Neshannock Creek on the right. Here, Jefferson Street runs north through the center. Mill Street Bridge is on the lower right. Although the Redevelopment Authority leveled many downtown properties, some landmarks remain. St. Mary's Church is at center, and farther down is the First Christian Church and the old post office building.

Two

BUILDINGS

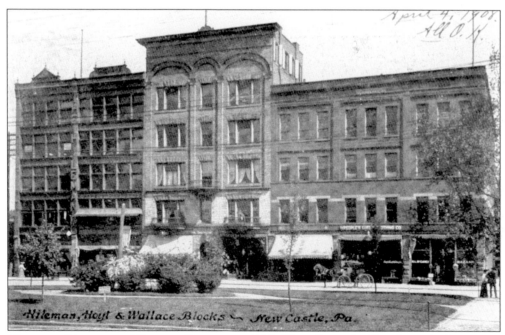

HILEMAN, HOYT, AND WALLACE BLOCKS, C. 1908. The Hileman building housed a department store. In 1910, New Castle's first public library moved into the second floor. Offices were in the Hoyt Block, including those of the Hoytdale Coal Company. In the Wallace Block were dry goods and clothing stores. Attorney William D. Wallace maintained offices there. These lots are now parking spaces for Eckerd's Drug Store.

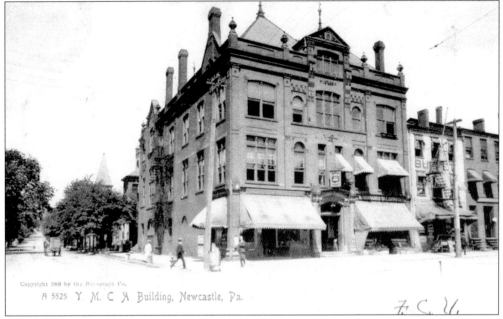

Copyright 1905 by the Rotograph Co.
A 5525 Y. M. C. A. Building, Newcastle, Pa.

FIRST YMCA BUILDING, 1906. Ira D. Sankey was a singing evangelist and composer of hymns. He was also an officer of the YMCA. As his hymns gained popularity, he was able to use income from their sale to buy a building for the YMCA in 1885. The building stood on the Diamond at the northeast corner of Jefferson and Washington Streets.

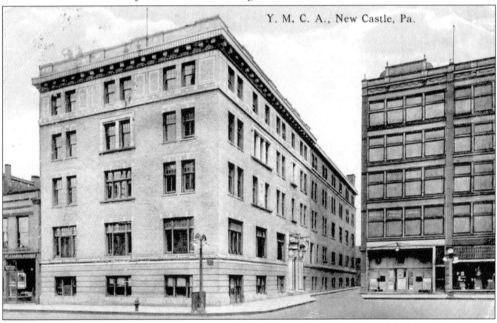

Y. M. C. A., New Castle, Pa.

SECOND YMCA BUILDING, 1915. In 1911, the YMCA moved into its new building on the northwest corner of Washington Street and Diamond Way. Thanks to a successful fund drive, this new building offered a swimming pool to its members. The new building displaced the Shenango Hotel and the New Castle Employment Office. In 1963, another new building replaced this one. It is now called the Community Y after a merger of the YMCA and YWCA in 1984.

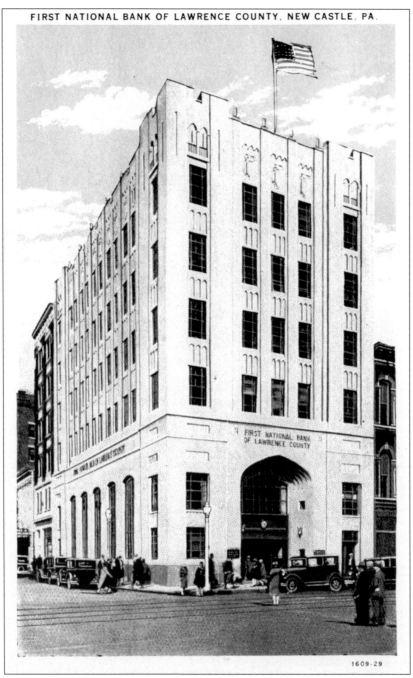

1609-29

FIRST NATIONAL BANK OF LAWRENCE COUNTY. The First National Bank of Lawrence County was organized around 1891. It was first located on the north side of East Washington Street between North Mill and North Mercer Streets. In 1927, the bank moved west to the corner, occupying a handsome new gray building designed in a modified art deco style. The chief architect was George Simon. As much as possible, the construction firm used material produced in New Castle. After several changes of ownership, the building is now Sky Bank.

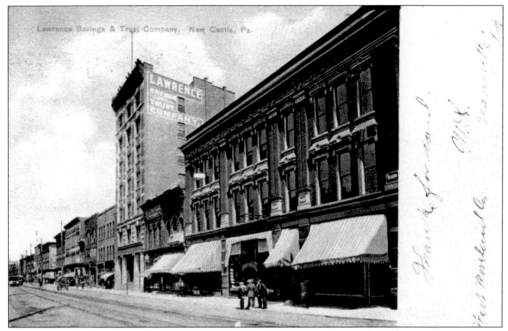

LAWRENCE SAVINGS AND TRUST COMPANY. The tall building in the center was constructed in 1903. Among its tenants were two architectural firms, Thayer and Eckles; several limestone companies; the New Castle Chamber of Commerce; law offices; a coal company; and a cement company. Polished granite, cut stone, and brick were used to construct the building. When it was demolished by the New Castle Redevelopment Authority in the 1970s, it was said to be difficult to tear down.

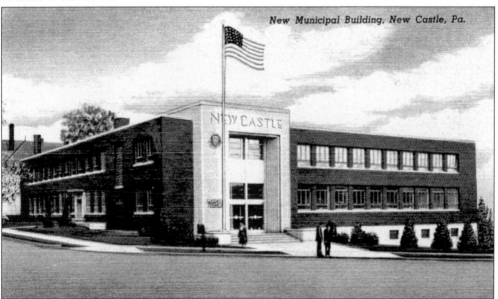

NEW CITY BUILDING. In 1949, New Castle's city government moved from Washington Street to this new municipal building. John F. Haven was mayor. The police department, which occupied a portion of the old building, also moved. The building stands midway up Jefferson Street Hill on the southeast corner of Jefferson and Grant Streets.

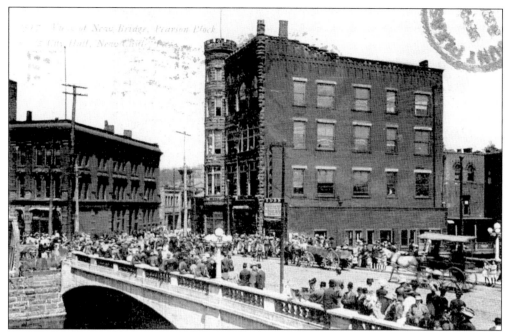

PEARSON BLOCK AND CITY HALL, 1911. This view from Washington Street Bridge shows the city hall to the left, on the corner of East Street, and the Pearson Block at the center. Work on the city hall began in 1875, but a fire in 1876 destroyed it. It was rebuilt and opened several years later.

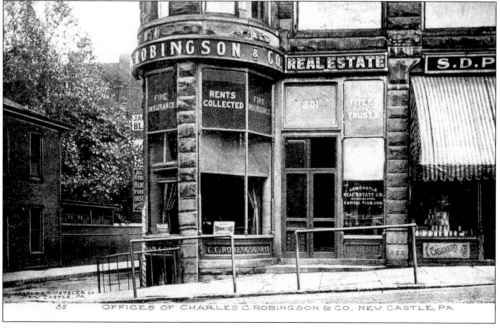

PEARSON BLOCK (JOHNSON BUILDING), 1907. Before this building was demolished in 1973, it was occupied by a variety of tenants such as the U.S. Post Office, Butz Flowers, a tobacco shop, and, as seen in this postcard, Robinson's Real Estate Company. When George Johnson of Johnson Limestone Company bought the building in 1917, it was renamed the Johnson Building.

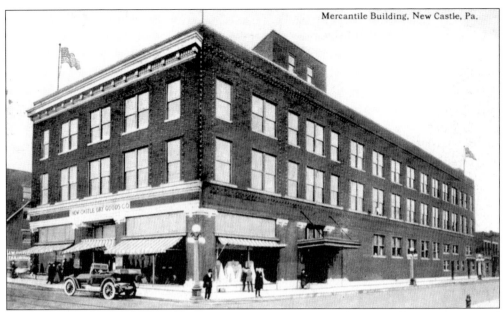

MERCANTILE BUILDING, 1914. This building, at the corner of East Washington Street and Croton Avenue, replaced the smaller McCandless Building in 1912. When the New Castle Dry Goods store moved in, the building became known as the Dry Goods Building. In the 1940s, the store's snack bar had the best frosted malted cone in town. In later years, the Dry Goods Company was bought by the Troutman Company from Butler, Pennsylvania. Troutman's closed in the 1980s.

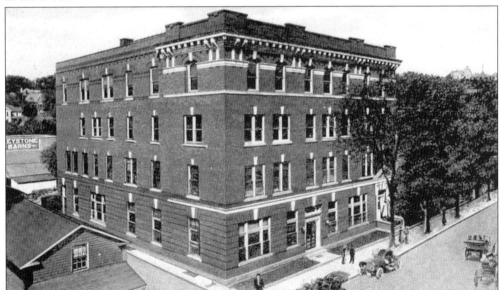

MASONIC TEMPLE, 1922. The Temple Building on North Street is a few doors west of Mill Street. It was built in 1905. The Masons occupied the third and fourth floors until the Scottish Rite Cathedral was built in the mid-1920s, and the Lawrence Club occupied the first and second floors until 1925. The Lawrence Club, founded in 1896, was a social club for bankers and industrialists. They occupied temporary premises for two years, then in 1927 moved into the Castleton Hotel.

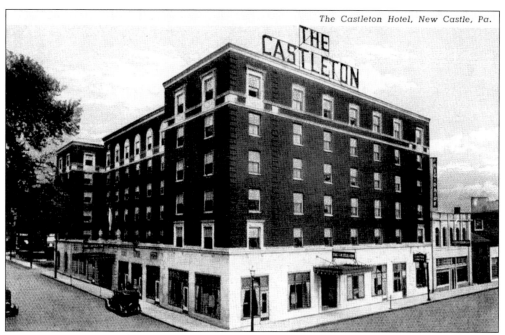

THE CASTLETON HOTEL. Although it is now an apartment building, the Castleton is a reminder of the number of travelers who used to visit New Castle. Built by Thayer Architects in the 1920s, it set a standard for elegance, particularly in the dining room where Friday night smorgasbords were featured in the 1950s. The Lawrence Club has met there since 1927.

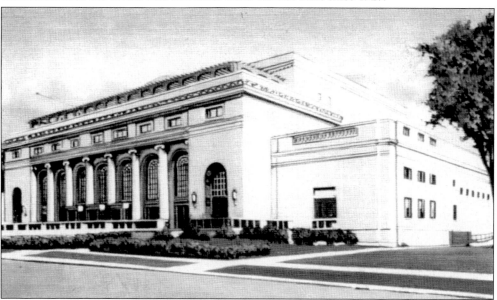

SCOTTISH RITE CATHEDRAL. The cathedral sits on a hill overlooking downtown New Castle. It opened in 1926 on Lincoln Avenue between Highland Avenue and North Mercer Streets. Built as the meeting place of members of the Ancient Accepted Scottish Rite, it offers banquet space, a ballroom, and a 3000-seat auditorium. The cathedral has been the venue for graduations, dance recitals, orchestra concerts, film festivals, and other major gatherings. It housed a movie theater in the 1930s and radio station WKST in the 1940s and 1950s.

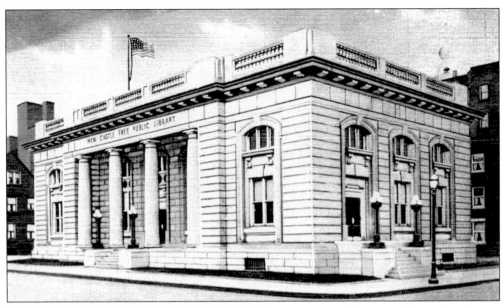

U.S. POST OFFICE AND PUBLIC LIBRARY. In 1893, the post office moved from the Johnson Building to 42 South Mercer Street, then, in the early 1900s, to this building on the southeast corner of North and Mercer Streets. In 1938, this building became the home of the New Castle Public Library, which from 1925 to 1938 had occupied the remodeled Hoyt mansion on the southwest corner of Jefferson and North Streets. Since 1981, the library has been on the northeast corner of Mill and North Streets.

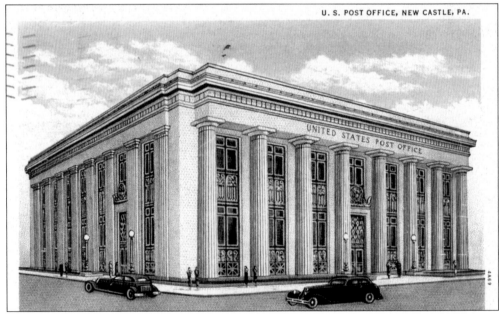

U.S. POST OFFICE, 1935. The W. G. Eckles Company, New Castle architects since 1899, drew this sketch of the post office building to be located on the southwest corner of the Diamond. In the late 1980s, the main post office relocated to Cascade Street and the downtown area is served by the Cascade Galleria station on South Jefferson Street. This impressive structure is now an office building.

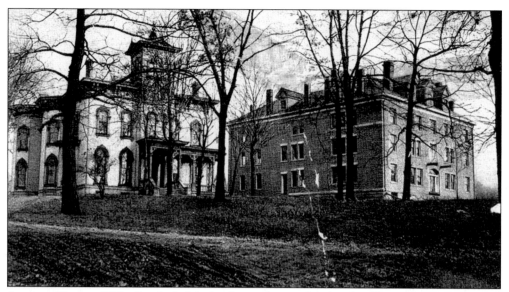

ALMIRA HOME, 1908. On the left is the former home of Colonel Dallas C. Irish, a Civil War veteran. It was acquired by the city in 1893 for use as a residence for elderly women. Located on East Washington Street near Almira Street, the residence was named Almira Home for Almira P. Martin, who had originated the idea of a home for women. A new Almira Home (right) opened around 1910, and the Irish house continued to stand until the 1940s.

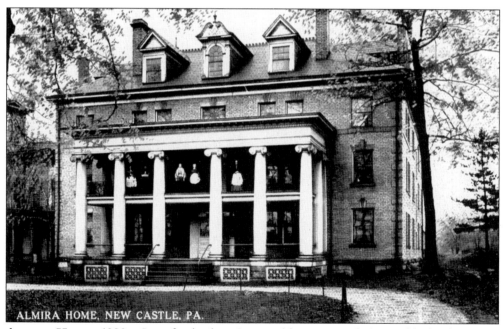

ALMIRA HOME, 1920s. State funds, donations, and bequests made it possible for the city to move the Almira Home into a new building, pictured here. The residence eventually admitted men in need of assisted living. Although the Almira Home closed around 1999, the Almira Foundation continues the name. The building is now owned by Lawrence County and is occupied by Lawrence County's Children and Youth Services and other county agencies.

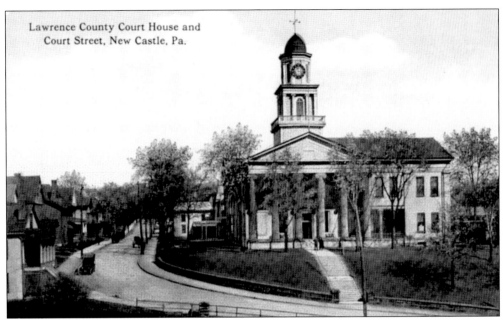

Lawrence County Court House and
Court Street, New Castle, Pa.

COURTHOUSE, 1922. In 1849, New Castle was situated on the line between Beaver and Mercer Counties. The complications of sorting out jurisdictions led to the formation of Lawrence County. At first, the new county's court sessions were held in the Methodist Church on South Jefferson Street (later St. Joseph's). The courthouse opened in 1851 on East Washington Street (then Pittsburg Street) between Court and Countyline Streets. Although additions have been made, the original building is still standing.

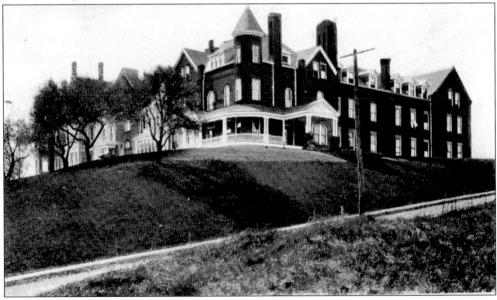

SHENANGO VALLEY HOSPITAL, 1907. New Castle's first hospital was above Grant Street on the southwest corner of Lincoln Avenue and North Beaver Street. It was built by Thayer Architects on the estate of I. N. Phillips. The new hospital was ready for use in 1893, but after a fire destroyed it, it was rebuilt with firewalls and opened in 1894. The building was closed in 1929, and the hospital merged with the new Jameson Memorial Hospital.

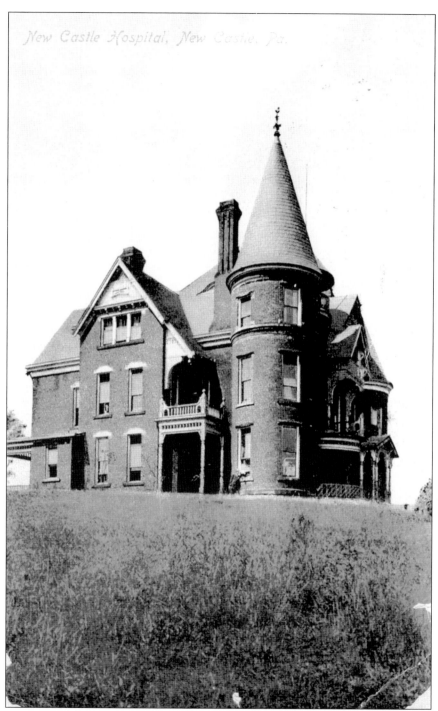

NEW CASTLE HOSPITAL, 1911. In 1908, the Sisters of St. Francis acquired the home of T. M. Phillips, located on the hill between South Mercer and Phillips Streets, bounded by Lutton Street. They converted it into a 35-bed facility, calling it the New Castle Hospital. The fee for care was $1 a day, or free to the impoverished. As the second hospital in New Castle, it was situated to serve the South Side and East Side communities, as well as Sheep Hill and Mahoningtown.

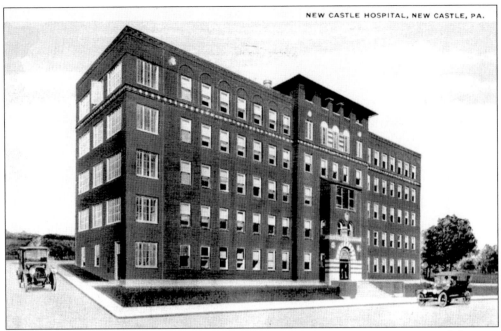

NEW CASTLE HOSPITAL, 1944. Needing to expand, the Sisters of St. Francis opened this new building in 1919. In 1939, they added a nursing school and residence. The hospital was renamed St. Francis Hospital in 1964. In 2002, its assets were acquired by Jameson Memorial Hospital and the building is now the south campus of the Jameson.

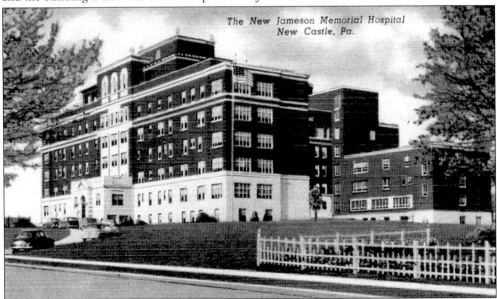

JAMESON MEMORIAL HOSPITAL, 1940s. This hospital and its adjoining nurse's home opened on Leasure Avenue in 1929. It was named for the family of benefactor David Jameson, a local banker and attorney. The hospital has become New Castle's largest employer, steadily expanding its capabilities with changes in medicine and technology. This building, now expanded north, is called the north campus, the main location for patient care. It is on the southwest corner of Wilmington Road at Garfield Avenue.

Three

BRIDGES, STREETS, AND HOUSES

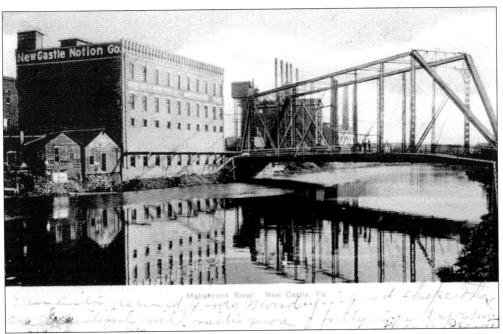

MILL STREET BRIDGE, 1907. This bridge still crosses Neshannock Creek (not the Mahonnock, as the postcard says). Located in the heart of New Castle's business center, the Rosena Furnace can be seen in the distance. The New Castle Notion Company went out of business in 1974, but the building still stands.

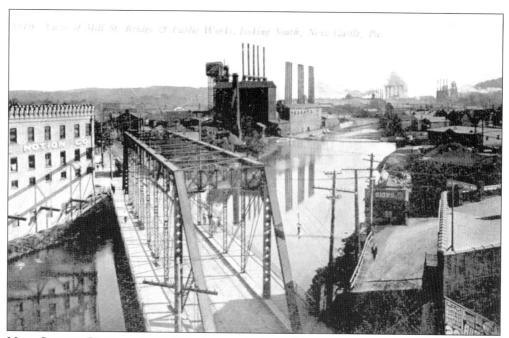

MILL STREET BRIDGE, 1913. This is a good view of the Rosena Furnace and the Carnegie Mills from the Mill Street Bridge. Streetcars running across the bridge connected New Castle's South Side with the businesses on East Washington Street. The thoroughfare on the lower right is Water Street.

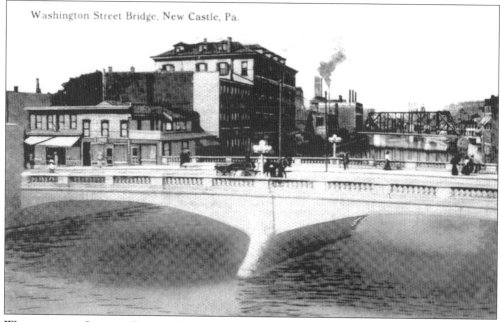

WASHINGTON STREET BRIDGE LOOKING SOUTH, 1913. This bridge over the Neshannock Creek connected the central business district and the Diamond (west) with the Mercantile Building, Dean Block, and the courthouse (east). The Mill Street Bridge is in the distance. The Dean Block, built in 1902, came down in 1989.

View on The Neshannock, New Castle, Pa.

WASHINGTON STREET BRIDGE LOOKING NORTH, 1913. The Neshannock Creek is calm in this view. The Dean Block on the right houses the New Castle Business College. Rohrer's Gun Store can be seen on the left. At the lower left are New Castle Produce and other Water Street vendors tending to their customers.

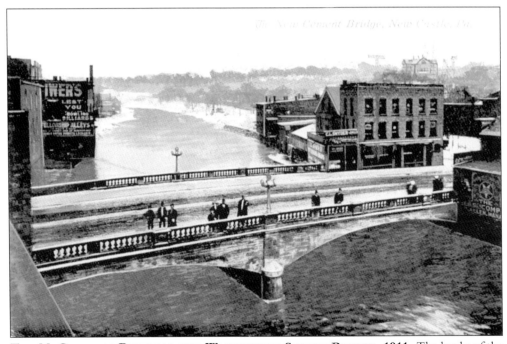

THE MCCANDLESS BUILDING AND WASHINGTON STREET BRIDGE, 1911. The banks of the Neshannock are covered in snow in this winter scene. A grocery store occupies the McCandless building on the right. Snyder's is in the small building next door.

35

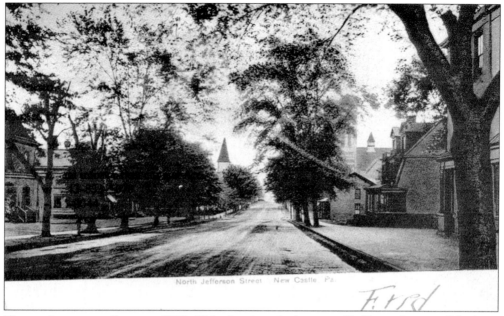

NORTH JEFFERSON STREET, 1908. This view is at the bottom of Jefferson Street Hill looking south toward the Diamond. The First Methodist Church steeple can be seen in the center distance, and the First Presbyterian church can be seen right of center. The street was clearly a residential street in the early 1900s, with large homes set back from the curbs.

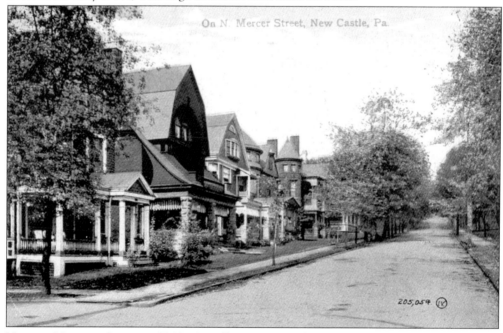

NORTH MERCER STREET, 1916. At Falls Street, North Mercer Street begins to go uphill. The next block, starting at Grant Street, is a challenge because the hill suddenly gets quite steep. The large houses on the hill include those of R. W. Clendenin and William Patterson. Clendenin owned a department store, and Patterson was vice president of the National Bank of Lawrence County.

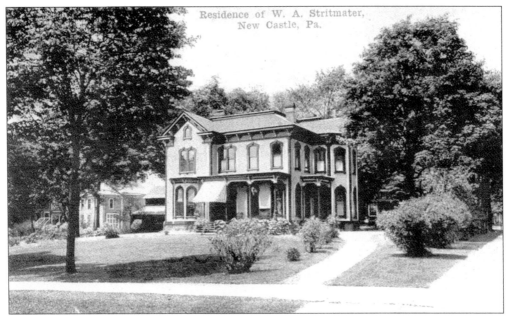

RESIDENCE OF W. A. STRITMATER, 1910. This house, somewhat altered now, still stands on the northwest corner of Lincoln Avenue and North Mercer Street. Its first owner, William A. Stritmater, and his brothers Joseph and James, operated a store dealing in dry goods, millinery, carpets, tailoring, and boots and shoes. The Stritmater name can be seen at the top of their building, which still stands at 126 East Washington Street.

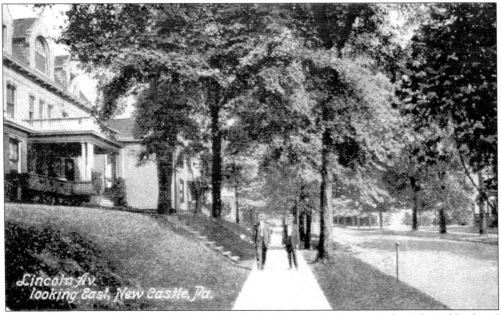

LINCOLN AVENUE LOOKING EAST, 1910. Lincoln Avenue was a quiet residential neighborhood when this photograph was taken. Within a year, New Castle High School would open on Lincoln Avenue and the character of the neighborhood would change. Noah Elliott of Elliott-Blair Steel Company was one of the prominent industrialists living on this street. This view looks east from Highland Avenue.

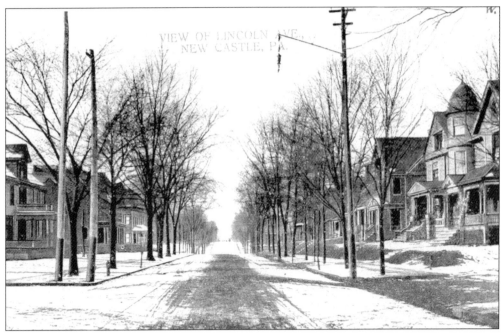

LINCOLN AVENUE LOOKING WEST, 1910. This snowy scene looks toward Highland Avenue from Reis Street. The first house on the right is that of William C. Harbison, who was in the insurance business. Shortly after this photograph was taken, an estate across the street would be cleared so that the New Castle Senior High School could be built.

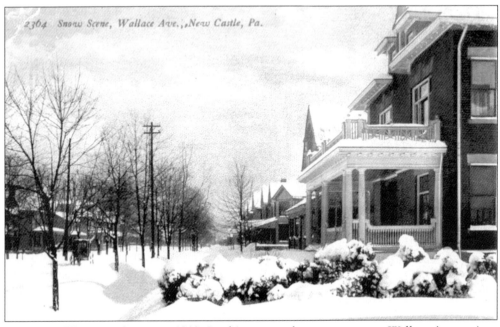

A SNOWY WALLACE AVENUE, 1910. Looking east, a heavy snow turns Wallace Avenue into a winter wonderland. This home on the right is typical of the large ornate houses on the street. Although many of them have been altered in some way, most of the houses are still standing.

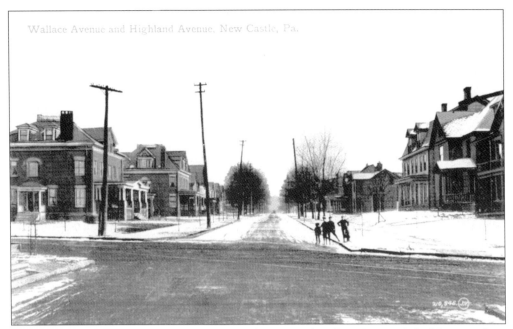

WALLACE AVENUE LOOKING EAST, 1910. This view of Wallace Avenue is looking east from Highland Avenue. The large house to the left is no longer standing. It was occupied by the family of Samuel Foltz, an officer at the First National Bank. Note that Highland Avenue, a main thoroughfare, has been cleared for streetcar traffic.

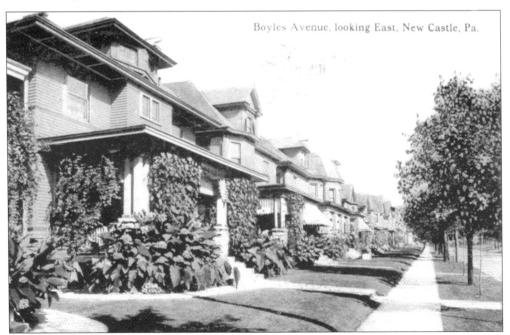

Boyles Avenue, looking East, New Castle, Pa.

BOYLES AVENUE LOOKING EAST, 1913. As New Castle's population grew, so did its neighborhoods. These houses are on the north side of Boyles Avenue in the 300 block. One of the residents, James Hamilton, New Castle's "poor" director, could walk with his Lincoln Avenue and Wallace Avenue neighbors to their offices in the center of town.

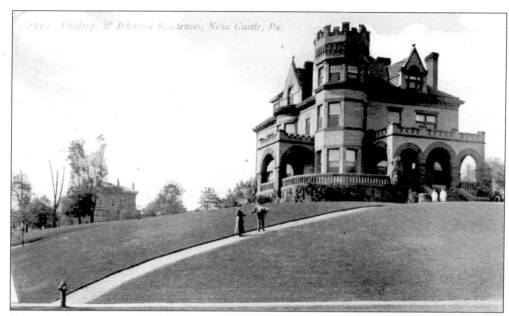

PHILLIPS RESIDENCE, 1911. This castle-like residence at the northwest corner of Highland and Moody Avenues was the home of Thomas W. Phillips, president of Phillips Gas and Oil Company. The house was torn down in the 1960s, and a church now occupies the site. In the background is the Johnson residence on Moody Avenue. It was the home of Charles Johnson, whose father, George, was the founder of the Johnson Bronze Company. The Johnson house is still standing.

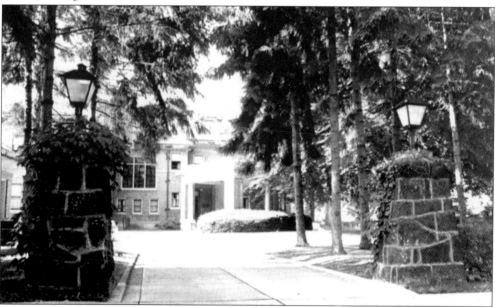

MAY EMMA HOYT MANSION, 1980. May Emma Hoyt and Alex Crawford Hoyt were sister and brother. In 1917, May Emma occupied this 22-room house on Leasure Avenue, and Alex and his wife lived in a 25-room house next door, on the corner of Leasure Avenue and North Mercer Street. The two mansions became the Hoyt Institute of Fine Arts in 1968. The Hoyt offers classes in fine arts and regularly mounts art shows.

Four

CHURCHES

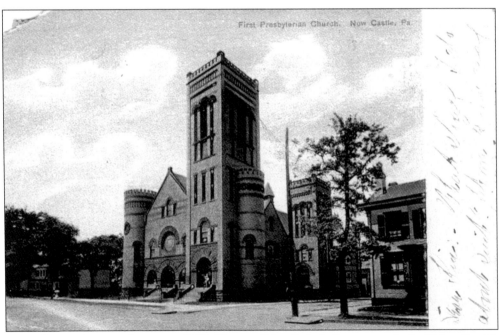

FIRST PRESBYTERIAN CHURCH, 1908. The year John Carlysle Stewart marked off New Castle's land, 1798, was the same year this church had its beginnings at a spring north of Grant Street, near Phillips Place. This view is of the church's fifth building, located on North Jefferson Street. Completed in 1896, it is distinguished by 15 magnificent stained-glass windows. Today, Easter sunrise services are held at the spring where the church began.

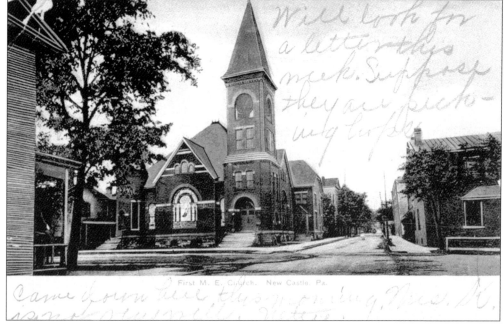

First M. E. Church. New Castle, Pa.

FIRST METHODIST EPISCOPAL CHURCH. This 1909 postcard shows the fourth church built by a congregation dating back to 1804. First was a log building at South Jefferson and Lawrence Streets around 1815, followed by second and third churches there. This fourth church went up in 1887 at North and North Jefferson Streets on ground donated by evangelist Ira D. Sankey. In the late 1960s, the church moved to Decker Drive in Neshannock Township and changed its name to First United Methodist Church.

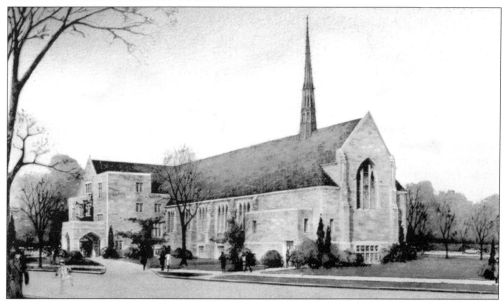

EPWORTH METHODIST CHURCH. In 1874, people living on the east side of Neshannock Creek wanted to found their own church. They built it on Pearson Street in 1875. After a fire, a new building was dedicated in 1886. The third church, seen in the architect's rendering here, was dedicated in 1931. It is located on Butler Avenue and East Washington Streets.

42

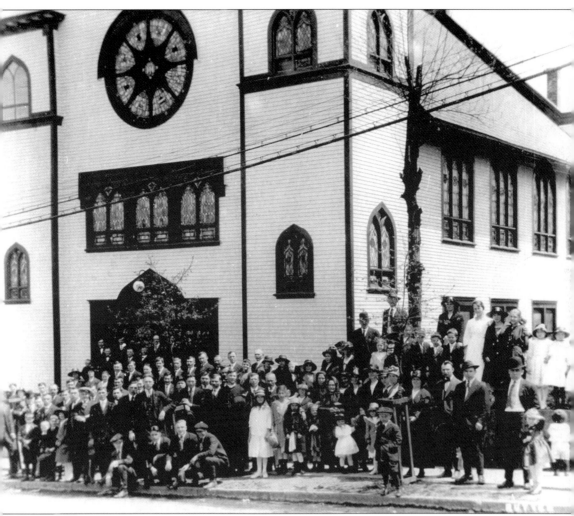

St. Michael's Church. In 1908, New Castle's Slovak community attended special masses twice a month at St. Joseph's Church, and by 1910, enough funds had been collected to build St. Michael's and to dedicate it as a Slovak ethnic parish. This photograph shows the parishioners in the late 1920s in front of the church at 1701 Moravia Street. Some of the family names identified in the picture are Hudak, Hruska, Melichar, Karsnak, Matis, Tizak, Palkowicz, and Duda. The growth of the community led to the building of a new church on the same site in 1967. In 1993, St. Michael's merged with other parishes to become St. Vincent de Paul parish. (Courtesy of Peggy Cwynar.)

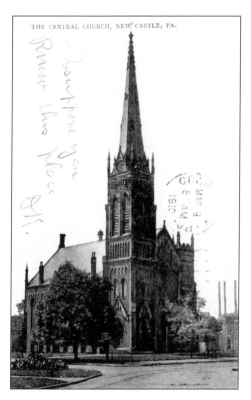

FIRST CHRISTIAN CHURCH. Perhaps the best known landmark in New Castle because of its steeple on the Diamond, this church was organized in 1856 in a building on North Street. The present church opened on the southwest corner of the public square in 1868. This view is from 1910. The steeple now has a clock, a gift from Grace Phillips Johnson in 1930.

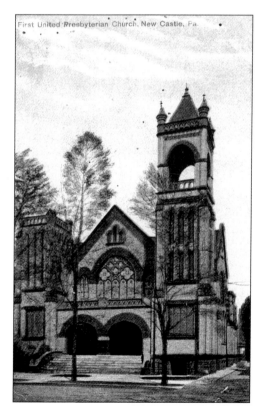

FIRST UNITED PRESBYTERIAN CHURCH. Organized in 1849, this church occupied its first building on the east side of North Jefferson Street near the Diamond. Its second church, in the same location, was dedicated in 1902. After a fire in 1927, the congregation moved to its present church on Clen-Moore Boulevard and Albert Street. The name was changed in 1958 to Clen-Moore United Presbyterian Church, and later to Clen-Moore Presbyterian Church.

S. S. PHILIP AND JAMES CHURCH AND RECTORY. This Polish ethnic church is at the corner of South Jefferson and Chartes Streets. It was founded in 1922, when the Polish population had outgrown Madonna, its first church. Dedicated in 1928, it merged with other ethnic churches in 1993 to become St. Vincent de Paul parish.

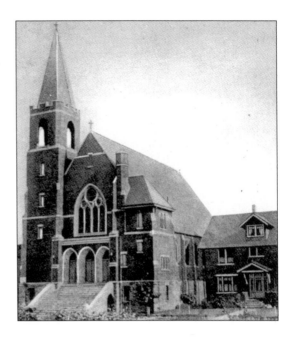

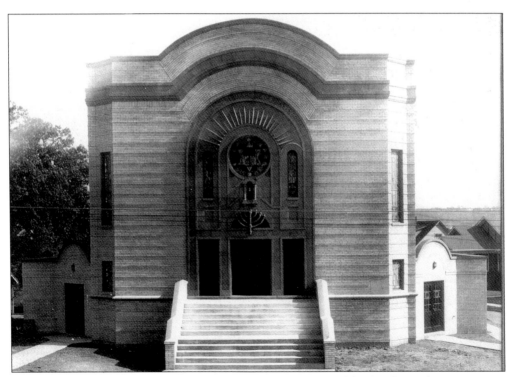

TEMPLE ISRAEL. The synagogue of Temple Israel, located at Highland and Moody Avenues, was dedicated in 1927. In 1997, the congregation merged with that of Tifereth Israel to form Temple Hadar Israel, which occupies the former Tifereth Israel synagogue at Moody Avenue and Logan Street. The Temple Israel building is still standing. (Courtesy of Temple Hadar Israel.)

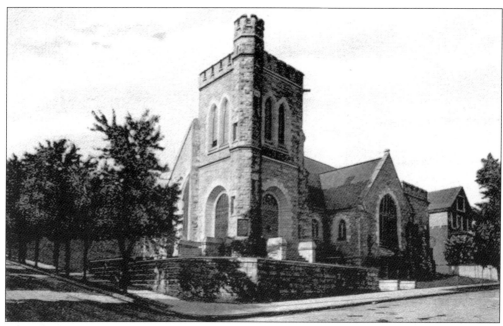

Trinity Episcopal Church. The first Trinity church opened in 1848 on East North Street. This picturesque building, at the corner of East Falls and North Mill Streets, opened in 1902. Its handsome design is executed in gray granite. Two stained-glass windows were designed by the renowned artist, Louis Comfort Tiffany.

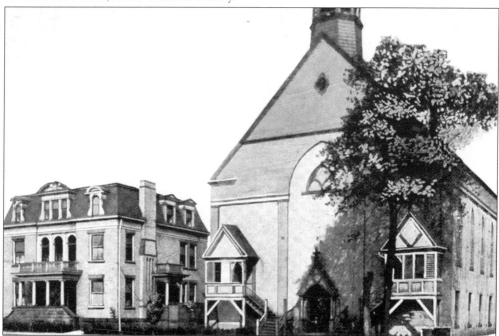

St. Joseph's Church. St. Joseph's was established as a German ethnic parish in 1888. It stood at South Jefferson and Lawrence Streets in a building purchased from the First Methodist Episcopal Church. After a fire in 1892, the church was rebuilt. This view is from 1908. In 1955, the parish built a new school on Cascade Street and broke ground for a new church there in 1962.

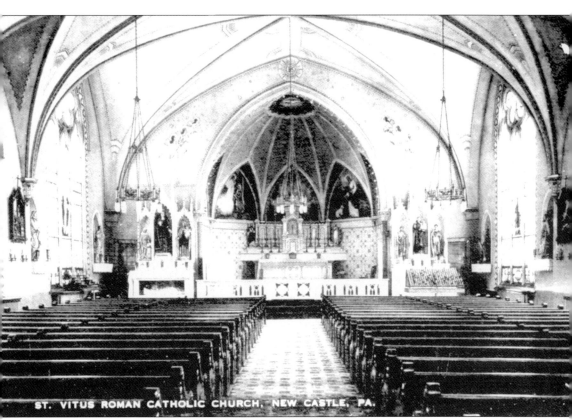

ST. VITUS ROMAN CATHOLIC CHURCH, NEW CASTLE, PA.

INTERIOR OF ST. VITUS CHURCH, *C.* **1920.** St. Vitus was the first Italian ethnic parish in New Castle, founded in 1900. Its pastor, Fr. Nicholas DeMita, first arranged to buy the Primitive Methodist Church on South Mercer Street. In 1907, he built a new church on South Jefferson and Maitland Streets with a convent and a playground close by. DeMita, a former professor of Greek and Latin, was also instrumental in establishing the new parish of St. Lucy in Mahoningtown to serve the growing number of Italian immigrants there. St. Vitus replaced the 1907 church with a new building on the same site. It was dedicated in 1963.

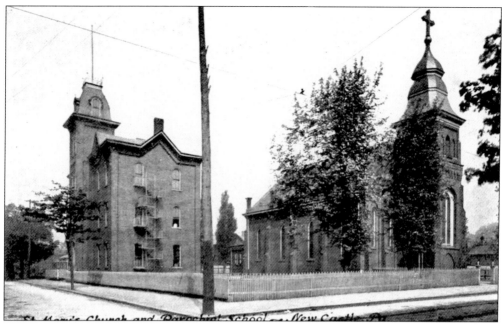

St. Mary's Church and Parochial School, c. 1909. St. Mary's was started by Father Reid in 1831, as a mission of a church in Beaver. From 1852 to 1871, the congregation met in a frame building at West Washington and Lowery Streets. In 1866, a new church building was started at Beaver and North Streets. The new church, seen here, was dedicated in 1871. The school was built soon after.

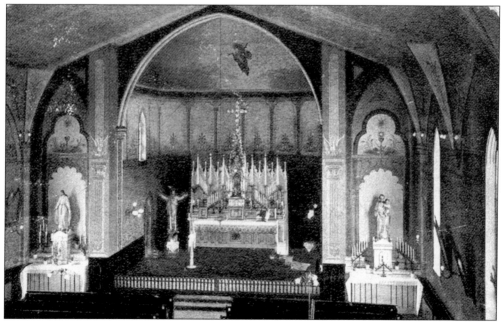

Interior of St. Mary's Church, c. 1909. St. Mary's was never identified as an ethnic church, but immigrants from Ireland seemed to outnumber other parishioners. This is the interior of the 1871 church, which was predominantly red brick. The central location of the church and school was convenient for the expanding congregation.

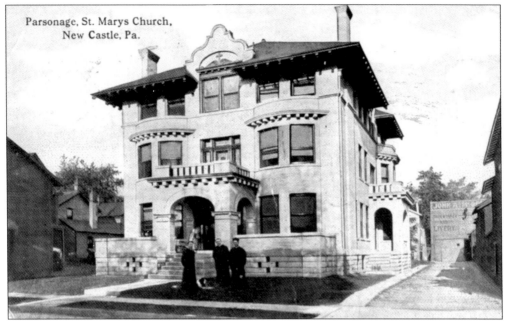

Parsonage, St. Marys Church,
New Castle, Pa.

PARSONAGE, ST. MARY'S CHURCH. In 1916, this rectory, on Beaver Street across from the second church, was built for the priests of St. Mary's. The postcard is also dated 1916. This gracious building still stands, serving a church that grew beyond expectations. The livery stable in the background faces North Jefferson Street.

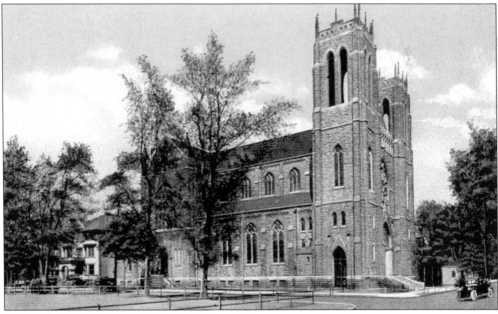

THE NEW ST. MARY'S CHURCH. The third St. Mary's, on North and Beaver Streets adjacent to the rectory, was dedicated in 1927. A new school and a social center came later. In 1993, St. Mary's and Madonna of Czestochowa parishes merged to become the new Mary, Mother of Hope parish. When the Madonna church building was sold in 2005, its 100-year-old bell was moved to St. Mary's.

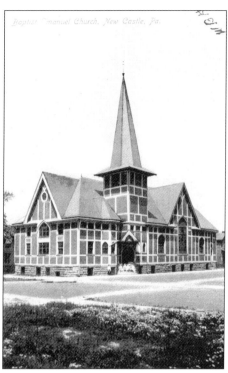

EMANUEL BAPTIST CHURCH. The first prayer meeting of the Emanuel Baptist Church was held at the home of William P. Williams on Long Avenue. After prayer meetings in members' homes, the congregation met in Elks and Hughes Halls. The church then bought property near South Jefferson and Reynolds Streets. The church was chartered in 1899. Lawrence County Housing Authority homes now occupy the former site of the church.

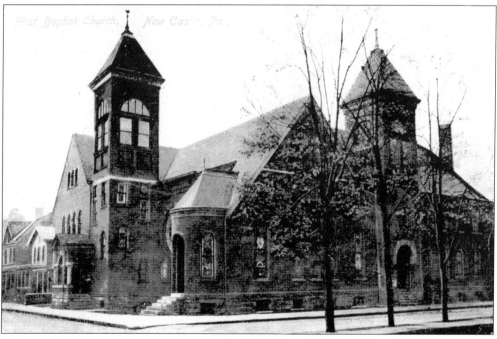

FIRST BAPTIST CHURCH. In 1843, a visitor from New Jersey, Mary Craven, founded this church at the northwest corner of North and East Streets. The first services were prayer meetings in a log house; the first church building was dedicated in 1849. The building seen here was started in 1889, enlarged in 1904, and taken down in the 1970s. The church is now on West Maitland Lane in Neshannock Township.

Five

SCHOOLS

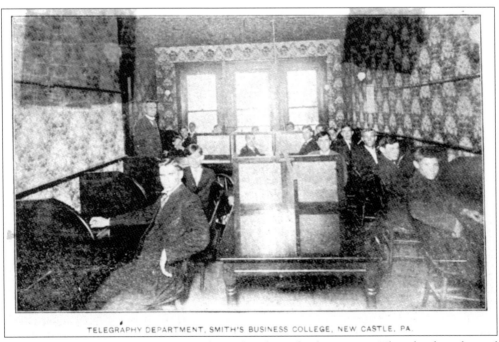

TELEGRAPHY DEPARTMENT, SMITH'S BUSINESS COLLEGE, NEW CASTLE, PA.

SMITH'S BUSINESS COLLEGE, 1907. This is the telegraphy department. The school was located in the Dean Block on South Croton Avenue. Ten months of shorthand classes cost $55, less $5 if paid in cash. A commercial course was slightly higher. In 1911, owner Isaac L. Smith took on a partner and changed the school's name to New Castle Business College.

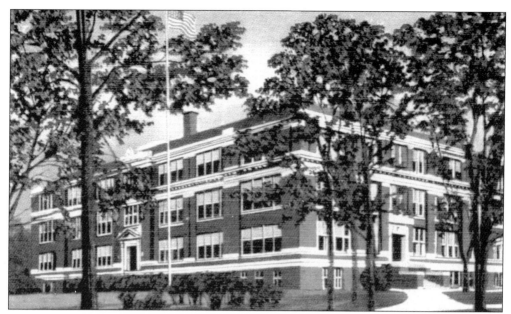

NEW CASTLE HIGH SCHOOL. New Castle High School was built on Lincoln Avenue in 1911. It was torn down in 2003 to allow a new school, already in construction in the same block, to extend to its site. The new, larger building opened in 2004 for high school students, and in 2005, junior high school students started classes there.

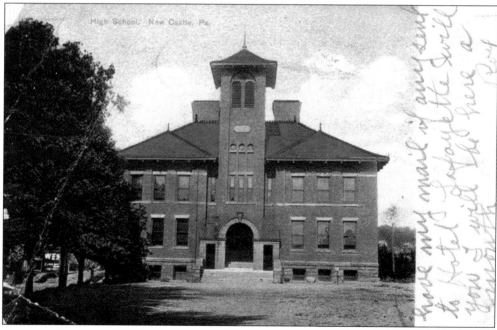

CROTON SCHOOL, 1907. Land northeast of downtown New Castle was donated by the Crowe family in 1828 and became Crowe Town, eventually shortened to Croton. This school, on the southeast corner of Croton Avenue and Cascade Street, was built in 1901. It was razed in 1962 to be replaced by a new elementary school and an administration building for New Castle schools. At that time, florist Paul Butz paid for the transfer of the old school bell to the new school.

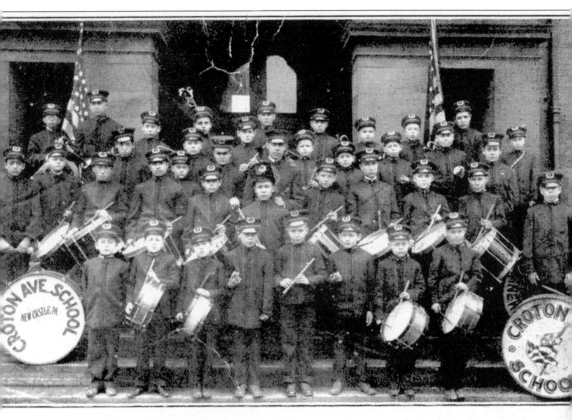

CROTON DRUM CORPS, EARLY 1920S. This is "The Crowd That Put the Crow in Croton." The Drum Corps started in 1914 with four members and eventually grew to 50. As soldiers left to serve in World War I, the Drum Corps led them to the trains. According to the postcard, "They went through sunshine and rain, and on one occasion, when the thermometer was below zero." Then the card added "They have done their bit in the Liberty Loan and Red Cross Campaigns, and are now out on all occasions to welcome the boys home." To honor the Drum Corps, New Castle citizens purchased the uniforms and equipment seen here. School principal and band leader Asa Hoffmaster is in the center.

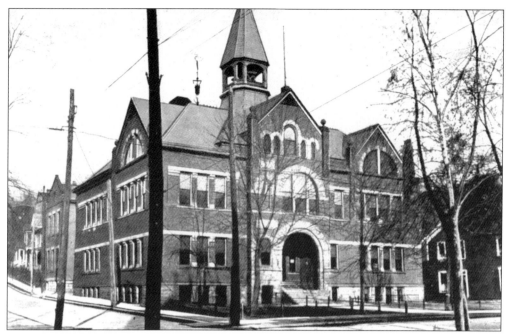

NORTH STREET SCHOOL, 1909. North Street School at the corner of East and North Streets served as the high school for New Castle students until the senior high school opened in 1911. It then became an elementary school. After a fire, the school was razed in 1952. A new building on the site housed administration offices for the New Castle schools, and later, the Universal Rundle Company. Sky Bank offices currently occupy the building.

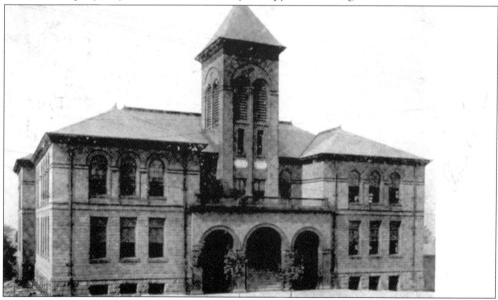

HIGHLAND AVENUE ELEMENTARY SCHOOL, 1907. This school was at the southwest corner of Highland and Laurel Avenues. When a fire burned most of the building in 1916, classes resumed in 1917 in a remodeled structure. That school was demolished in the 1960s, and a new school was built across the street on the southeast corner of Highland Avenue and Laurel Boulevard. The new school is called the Kennedy Primary Center.

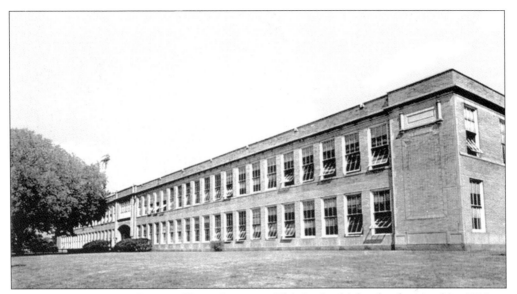

BENJAMIN FRANKLIN JUNIOR HIGH SCHOOL. This junior high school opened in 1922 on Cunningham Avenue and East Lutton Street. On the grounds was Taggart Field, where the senior high school football games take place. The school served students from the East and South Sides and the Croton area. The future of this building is uncertain because the new high school on Lincoln Avenue includes junior high classes.

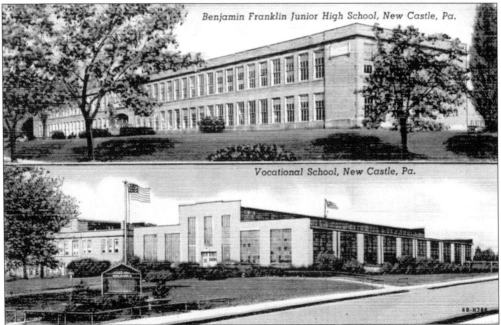

BENJAMIN FRANKLIN JUNIOR HIGH SCHOOL/VOCATIONAL SCHOOL. Until 1967, high school boys could elect to attend technical ("shop") classes in the building seen here next to Ben Franklin Junior High School. In 1967, Phillip Phelps brought to fruition a program of vocational preparation for all high school students. The county school known as Vo-Tech was built, and both girls and boys could be admitted. The name of Vo-Tech is expected to change to Lawrence County Career and Technical Center.

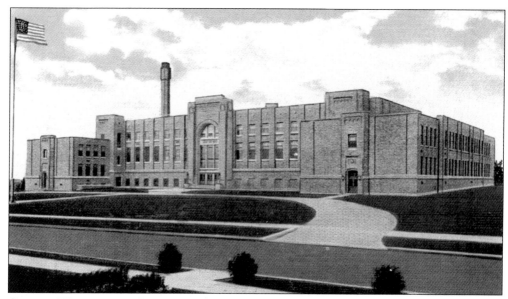

GEORGE WASHINGTON JUNIOR HIGH SCHOOL. This junior high school was built on Euclid Avenue at North Mercer Street in 1928. It was intended for students from the West Side and the North Hill, although students from Mahoning School occasionally transferred there for courses not available to them in their school. In 1988, George Washington became a city-wide intermediate school for grades four, five, and six.

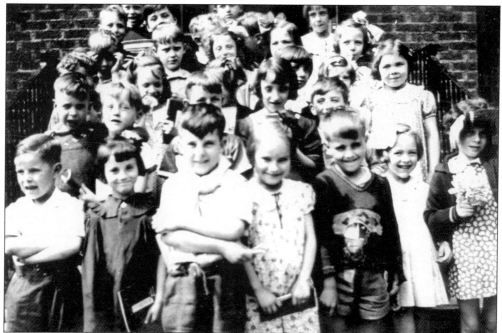

ARTHUR McGILL ELEMENTARY SCHOOL, 1937. The Arthur McGill School was built in 1922. It was located on Albert Street near Norwood Avenue, and near Clen-Moore Church and the George Washington School. This smiling group of children was in grades 1-A and 1-B. In the middle of the front row is Wally Coates. In the second row are Arthur Chapman on the left and Jane Throop on the right. In the fourth row is Arnold Lewis.

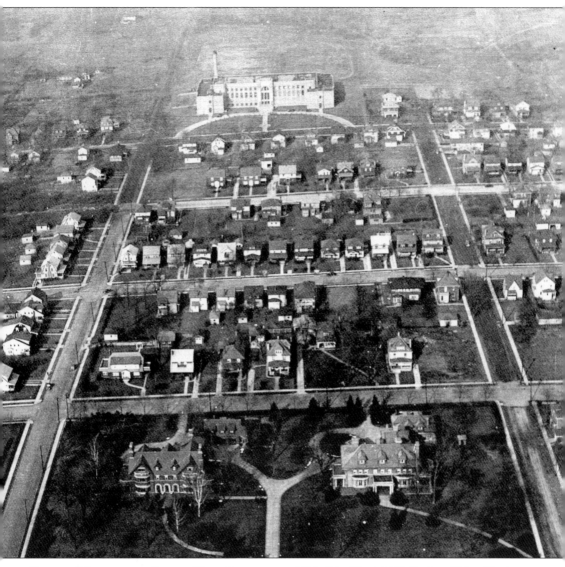

GEORGE WASHINGTON JUNIOR HIGH SCHOOL, C. 1928. The North Hill district of New Castle was sparsely populated when the George Washington School was built. This photograph shows the school at the top, on Euclid Avenue. The two mansions and estate of the Hoyt family can be seen at the bottom on Leasure Avenue. North Mercer Street is on the left. The Arthur McGill Elementary School is to the right, just outside the picture. Undeveloped areas seen here are now densely populated neighborhoods. (Courtesy of Lawrence County Historical Society.)

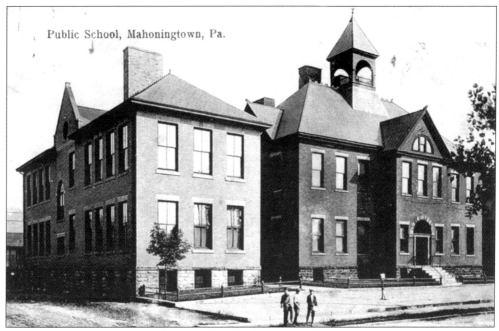

Public School, Mahoningtown, Pa.

MAHONING SCHOOL, 1911. The first school building in Mahoningtown was erected in 1838 on a hill north of the town. The school pictured here was built in 1893. By the time this photograph was taken, children of newly-arrived Italian immigrants were changing the way classes were taught because they did not speak English. Their teachers, who spoke only English, encouraged them and helped them to assimilate. This building burned down in 1915.

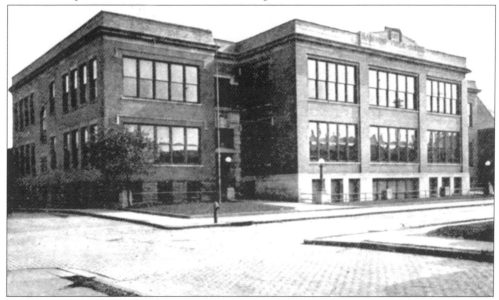

MAHONING SCHOOL, 1916. Mahoning School was rebuilt after the fire and reopened in September 1916. Classes ranged from first to ninth grade until 1958, when the seventh- through ninth-grade classes were moved to New Castle's junior high schools. Mahoning School closed in 1988, and the building was demolished in the early 1990s. Former students and teachers continue to attend reunions.

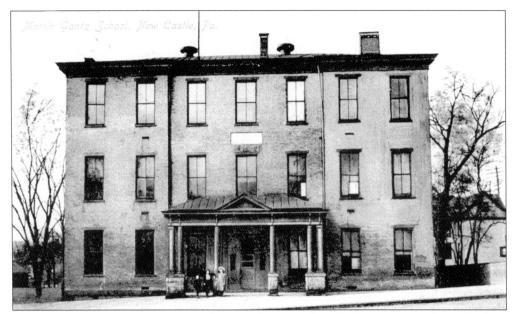

MARTIN GANTZ SCHOOL, 1909. This school, originally called Union School, was built in 1852 between Falls and Grant Street on the west side of North Jefferson Street. It consolidated four smaller schools. At that time, Martin Gantz was assistant to the principal. He eventually became superintendent of the city schools, and the school was ultimately renamed for him. It continued in operation until the 1930s.

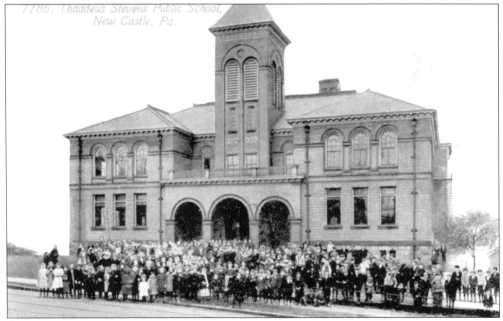

THADDEUS STEVENS SCHOOL, 1913. This elementary school is named for the school teacher who became a lawyer, Pennsylvania legislator, and U.S. Congressman who championed public school education for all children. This building, which opened in 1898, was located on the south side of East Washington Street at Harrison Street. It was replaced in 1963 with a new school facing Harrison Street.

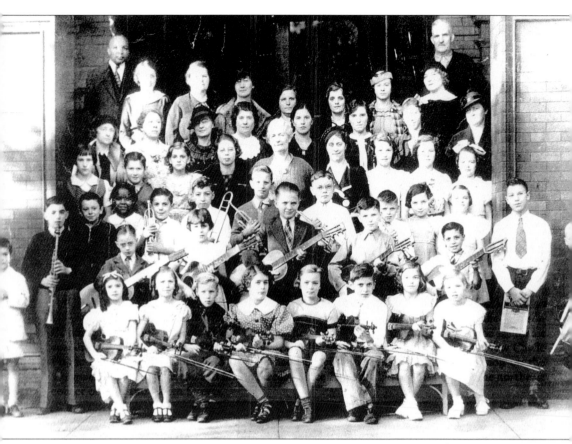

Thaddeus Stevens School Band, 1930s. Parent's Day was the occasion for this photograph. Anna Perry, the principal, is in the center of the fourth row (white hair), and Dr. Gillespie is in the back row on the left. Notice the number of violinists and guitarists. Anne Singer Hoye, in the middle of the first row (dotted dress) is active today as a violist.

Six

WORK

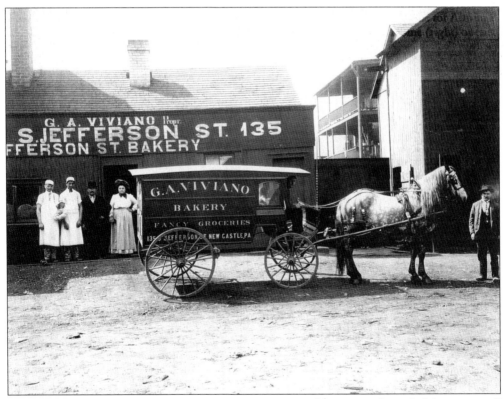

VIVIANO BAKERY, EARLY 1900s. G. A. Viviano came to this country from Colobraro, a small town in the Basilicata region of Italy. This building faces Grove Street. In 1913, Viviano added a store (to the right), fronting on South Jefferson Street. After his death, his wife continued to operate the store until the early 1980s. The brick building now houses a video rental store. The older building, seen here, is still standing behind the store. (Courtesy of Mary Viviano DeAngelis.)

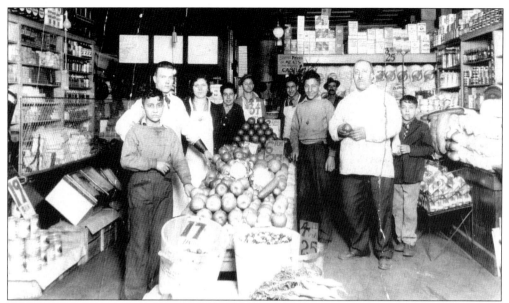

JOSEPH'S MARKET, C. 1918. After Moowid Joseph came to this country from Lebanon in 1915, he opened this market at 14 East Long Avenue. In the photograph from left to right are Moowid's son Tom, Joe Georgeski, unidentified, Pete Beshara, unidentified, Alex Beshara, Moowid's son George, unidentified, Moowid, and his son Joe. (Courtesy of George and Dennis Joseph.)

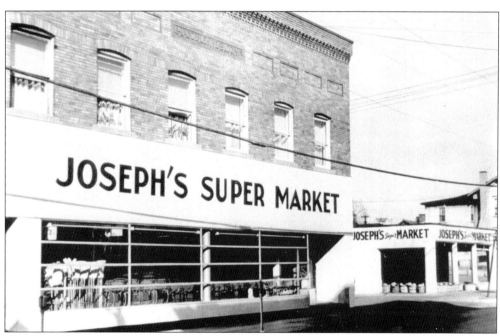

JOSEPH'S SUPER MARKET, 1950s. The original Joseph's Market moved across Long Avenue in the late 1920s. Although the store was on New Castle's South Side, it drew customers from around the city because of its specialized products, particularly those from the Middle Eastern countries. The store is now located in downtown New Castle on East Lawrence Street. Moowid Joseph's grandsons George and Dennis are the owners. (Courtesy of George and Dennis Joseph.)

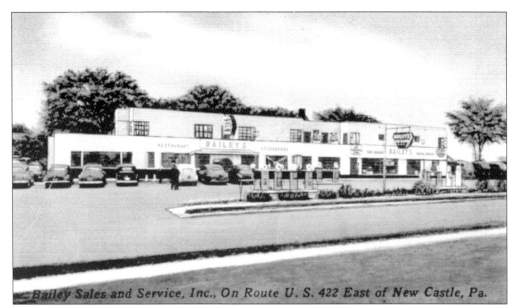

Bailey Sales and Service, Inc., On Route U. S. 422 East of New Castle, Pa.

BAILEY SALES AND SERVICE. Opened in the early 1930s on Butler Avenue, Bailey's was a popular truck stop. It offered gas, oil, showers, steam-heated cabins, and a restaurant to long-distance truckers. Students began to hang out at Bailey's in the 1950s because it stayed open to late hours. The business changed hands over the years and is now the New Fifties Diner, minus the cabins and showers.

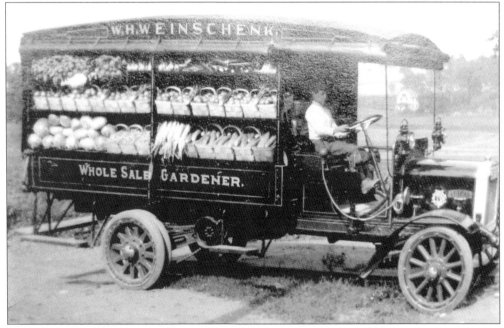

WEINSCHENK'S GREENHOUSE. William H. Weinschenk was well known as a grower of vegetables for wholesale markets. He built his first greenhouse in 1897 and expanded his business on Savannah Road and Denny Drive. An early geography book used in grade schools included a picture of a Weinschenk greenhouse and described it as the largest greenhouse in the country under one roof. (Courtesy of Joseph Weinschenk.)

ADVERTISING POSTCARD, M. LOY HANNA, C. 1900. This card was printed in full color to advertise pianos manufactured by Foster and Company in Rochester, New York. The back of the card carries the stamps of M. Loy Hanna's piano and organ store and Hanna and Eroe's optical department. These Hannas were part of the establishment of W. C. Hanna and Sons, dealers in pianos, organs, jewelry, and optical goods, who were New Castle merchants in the 1880s. An advertisement in 1888 stated that Hanna's was the sole agent for the Rockford railroad watch. The advertisement claimed, "We will convince you that you can buy more for a dollar in our store than anywhere in Western Pennsylvania."

COMPLIMENTS OF

FLECKENSTEIN BROS.

Dealers in Boots and Shoes,

99 WASHINGTON STREET, NEW CASTLE, PA.

ADVERTISING CARD, FLECKENSTEIN BROTHERS, 1890S. The Fleckenstein Brothers were dealers in boots and shoes. Their store was on the north side of East Washington Street near the Diamond. They opened in the 1880s when there were 13 other shoe merchants and nine boot and shoe makers in New Castle. Fleckenstein's continued in business until 1899. This advertising card must have been costly to produce. The little angel is die-cut and hand-mounted on the card. She is in full color, with glitter sprinkled on her clothes. The lettering is in gold.

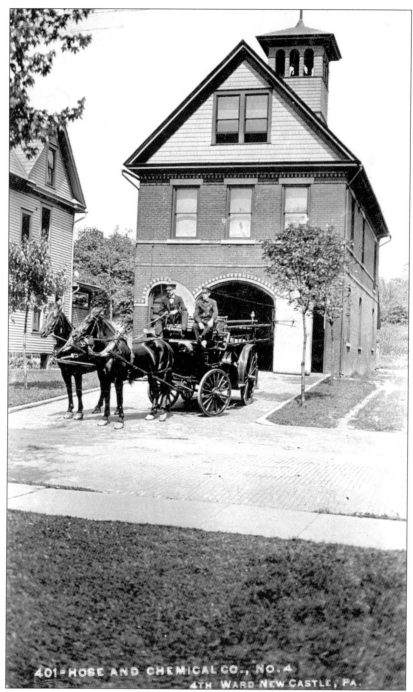

401-HOSE AND CHEMICAL CO., NO. 4
4TH WARD NEW CASTLE, PA.

HOSE AND CHEMICAL COMPANY, FOURTH WARD, 1913. In New Castle, fire engines were moved by hand until 1874, when the city authorized the purchase of a team of horses and a hook and ladder. The first motorized equipment was purchased in 1911. This fire company was established in the late 1800s, and the engine house shown here was located on Ray Street, near Pearl Street. It was an honor for this fire company to be chosen to head the big Independence Day parade in July 1910.

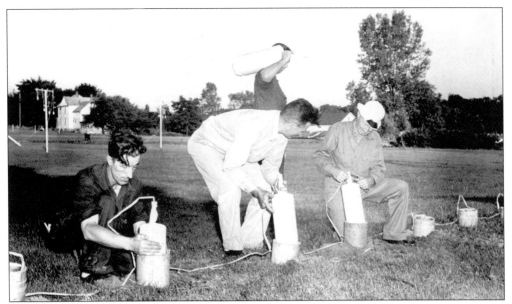

VITALE FIREWORKS. The fireworks industry in New Castle has a long tradition. In the 1890s, Italian immigrant Leopold Fazzoni started the first fireworks company. Jacob Conti, Paul Rozzi, and Constantino Vitale worked with Fazzoni and then went on to start their own companies. Vitale's company, now called Pyrotecnico, is run by his great-grandson Steven Vitale. In this photograph, the workmen are setting up a show by putting the shells into mortars. (Courtesy of Mary Jo Vitale Rossman.)

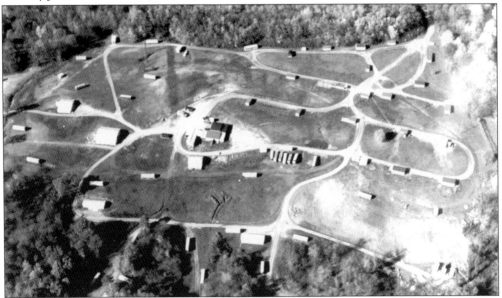

ZAMBELLI FIREWORKS PLANT. In the late 1940s, George Zambelli acquired the Fazzoni fireworks company. Today, Zambelli Fireworks Internationale is said to be the world's largest displayer of public fireworks. This aerial view shows the Zambelli plant on Wilson Road, with plenty of space between buildings in case of an explosion. George Zambelli's family now operates the business that helped New Castle earn the label "Fireworks Capital of the World." (Courtesy of Zambelli Fireworks Internationale.)

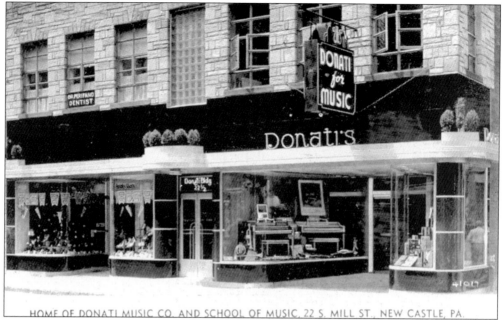

HOME OF DONATI MUSIC CO. AND SCHOOL OF MUSIC, 22 S. MILL ST., NEW CASTLE, PA.

DONATI MUSIC COMPANY, 1949. Opened in 1928, Donati's was located on South Mill Street near the center of town. The store offered musical instruments, records, sheet music, and music lessons. New Castle has always been a musical town, with enough business for this store, as well as the stores of Elizabeth Fleming, Francis Hammond, and Sam Marzano. This site is now a parking lot for what is described as a "revitalized downtown."

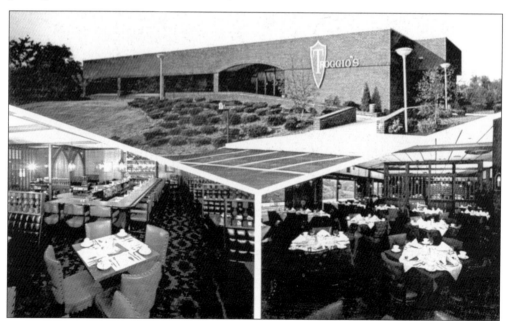

TROGGIO'S, LATE 1960s. First a café owned and operated by the Troggio family, this Butler Road restaurant featured live music for dancing in its bar, which was more like a night club. A favorite place for important dates and high school class reunions, Troggio's closed in the late 1990s. The building now houses medical offices.

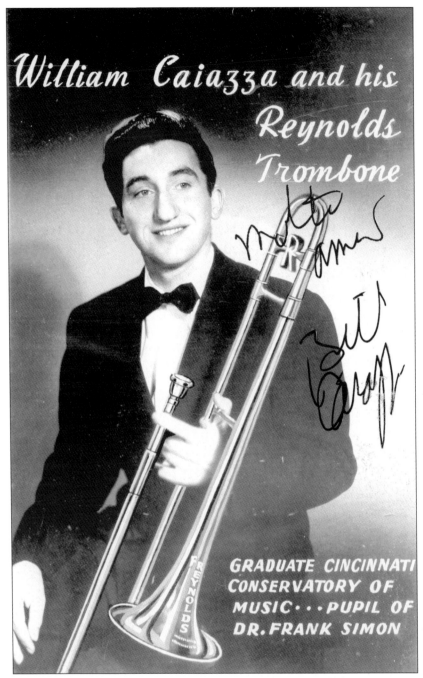

ADVERTISING POSTCARD, BILL CAIAZZA, 1950s. Like athletes, well-known musicians often endorsed products. In this postcard, Bill "Doc" Caiazza recommends Reynolds trombones. The Caiazza family was one of many musical families in New Castle. In the 1920s and 1930s, Anthony and Hugo played in other cities, as well as in New Castle. In the 1940s, Nick was a recording artist and he traveled with dance bands. In the 1950s, 1960s, and 1970s, Bill Caiazza went from the U.S. Army Band to Broadway shows, then to teaching, composing, and arranging in New York City.

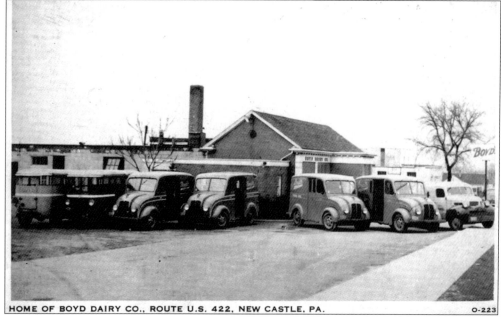

HOME OF BOYD DAIRY CO., ROUTE U.S. 422, NEW CASTLE, PA. O-223

BOYD DAIRY COMPANY, 1950s. In the early 1930s, Boyd Dairy replaced Love's Dairy on Adams Street. The business moved to Butler Avenue in the 1940s and continued there until the mid-1950s. A number of dairy farms around New Castle supplied Boyd's, Rieck's, Linger Light, and other retailers with their dairy products.

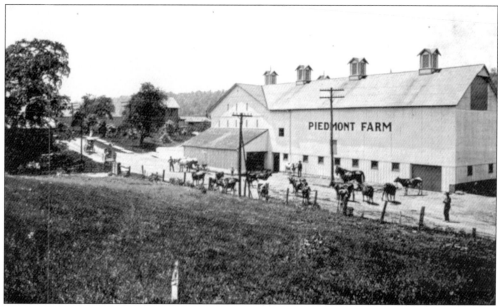

PIEDMONT FARM, EARLY 1900s. The Piedmont Farm is located outside of Mahoningtown off Route 18. First a dairy farm, its ownership has been traced back to the Gailey family in 1850 and possibly the Cochran family in the late 1800s, but it is probably older. It was acquired in 1939 by Harry Werner Sr. and is farmed today by Harry Werner Jr. Grant McConnell is standing at the lower right.

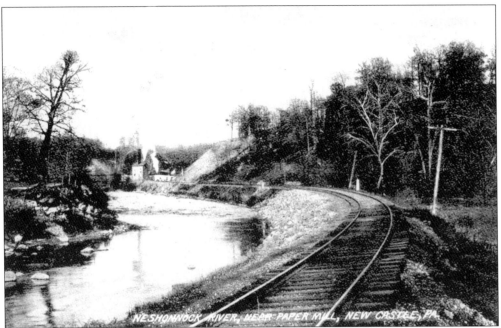

THE PAPER MILL, 1910. The paper mill was on the east side of Neshannock Creek near El Rio Beach. In 1868, it was known as the New Castle Paper and Sack Company. Later, it was the New Castle Paper Mill. It became the Dilworth Paper Company around 1891, then in 1914, it was called the New Castle Paper Company, operated by president James Cunningham until the mid-1920s. Today, Paper Mill Road leads to the site.

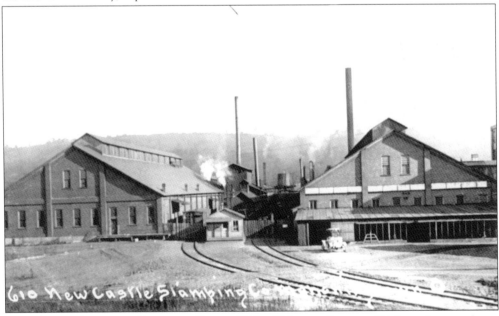

NEW CASTLE STAMPING COMPANY, EARLY 1900s. This manufacturer of high-grade enamelware employed 200 men. The process was based on German formulas applied with modern American methods. Located in Mahoningtown near the tin mill, the plant had access to the Pennsylvania, P&LE, and Buffalo, Rochester and Erie rail lines. It went out of business around 1912.

71

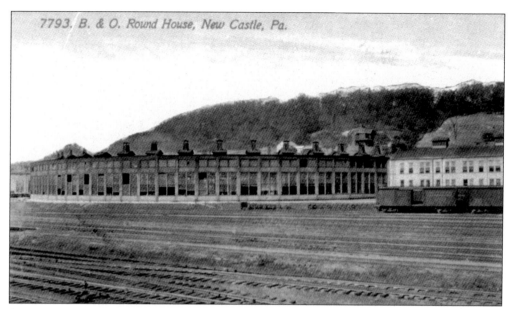

7793. B. & O. Round House, New Castle, Pa.

B&O Roundhouse, New Castle Junction. When a locomotive needs repairs, it is placed on a turntable that moves it into a bay in the roundhouse, where it can be repaired under shelter. As the B&O expanded its hiring in 1912, immigrants found work in these shops located between Mahoningtown and West Pittsburg. In 1940, many railroad workers were exempted from military service as the country prepared to go to war. In the same year, one million railroad cars were handled in these B&O yards.

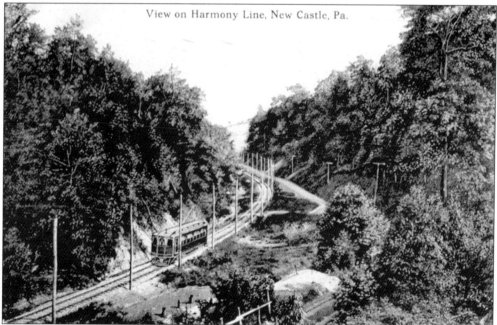

View on Harmony Line, New Castle, Pa.

Harmony Railway Line, 1917. The maroon and gold trolleys of the Pittsburgh, Butler, and Harmony Railway ran on narrow-gauge tracks. The cars ran hourly from Pittsburgh, with stops along the way to New Castle, including one at Cascade Park. The line opened in 1908 and continued until 1931. The car barn was on East Washington Street across from the courthouse.

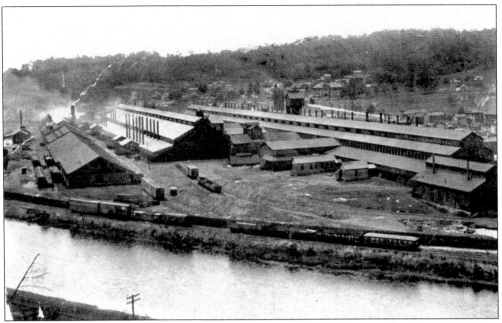

SHENANGO TIN MILL. In 1893, George Greer founded the first tin mill, calling it the New Castle Steel and Tin Plate Company. In 1897, Shenango Valley Steel built this tin mill. Then, in 1899, the two mills became part of the American Tin Plate Company, with Greer as manager. The mills brought in Welsh immigrants with manufacturing skills. This 1909 view shows the Shenango River, Mahoning Avenue, and in the background, Lawrence School.

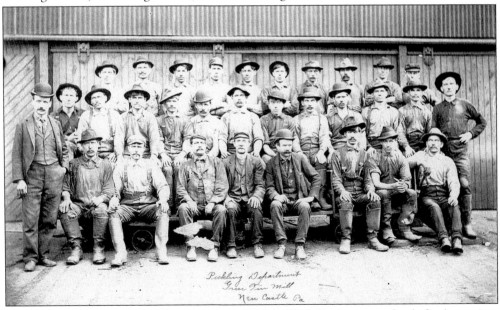

GREER TIN MILL PICKLING DEPARTMENT, 1904. In 23 A.D., tin was used only for decoration. By the 14th century, tin plating had become a useful craft, particularly in Bavaria. By the late 17th century, tin plating had spread to England. By the late 18th century, Welsh and Scotch-Irish immigrants were familiar with the process. Some of them are probably in this photograph. (Courtesy of Marilyn Koch.)

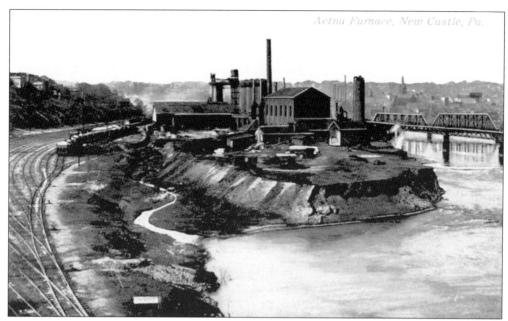

AETNA FURNACE. This view shows the Aetna Furnace on the west bank of the Shenango River looking north. The Lawrence Iron Company started in 1845 as the Aetna Ironworks, then built two Aetna Furnaces around 1867. By the 1880s, the furnaces employed 300 workers who produced 6,000 tons of finished bar iron and 120,000 kegs of nails a year. By that time, the Lawrence Iron Company once more took the name Aetna Iron Works.

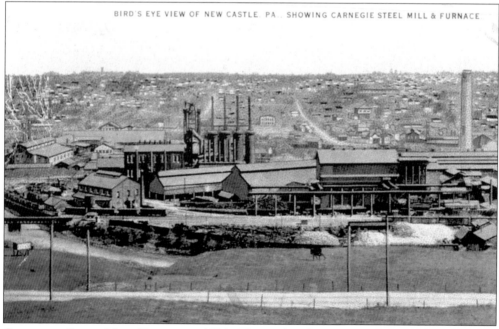

CARNEGIE STEEL MILL FURNACE, 1924. The steel mills were close to the center of New Castle, clustering in the area where the Neshannock Creek meets the Shenango River. In 1915, the mills were operating 24 hours a day. This postcard shows Atlantic Avenue in the foreground. Many remember the roar when the smokestack to the right came down in 1942.

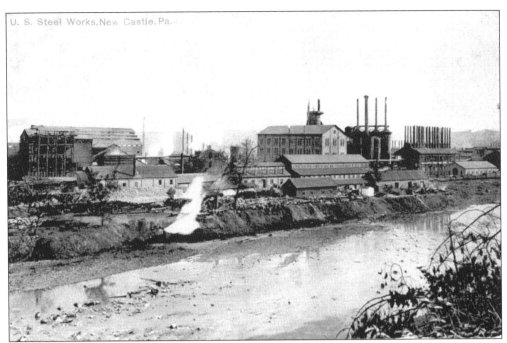

U.S. STEEL ON THE NESHANNOCK CREEK, 1910. U.S. Steel had its origins in the dealings of some legendary businessmen, including Andrew Carnegie, J. P. Morgan, and Charles Schwab. However, its principal architect was Elbert H. Gary, who also became U.S. Steel's first chairman. In the early 1900s, these businessmen bought Carnegie's steel company and combined it with the Federal Steel Company to form U.S. Steel.

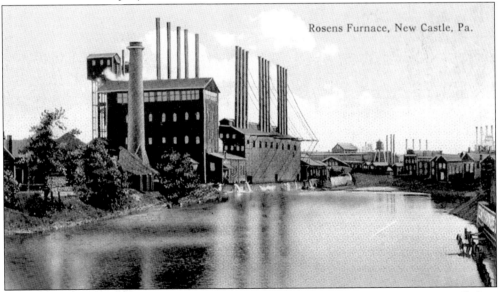

ROSENA FURNACE, LOOKING SOUTHWEST. The name of this blast furnace is misspelled on the postcard. It is the Rosena Furnace, named for Rosena Reis, the owner's daughter. Built in 1873, the furnace was part of the Shenango Iron Works, and later, Carnegie and U.S. Steel. It was located along the Neshannock on South Mill Street where Croton Avenue ends. The furnace stopped operating in 1925 and was dismantled in the 1930s.

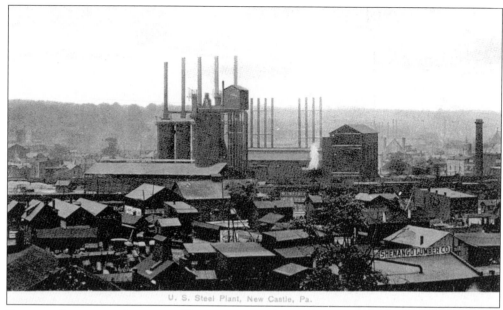

U. S. Steel Plant, New Castle, Pa.

ROSENA FURNACE, LOOKING NORTHWEST. This is the opposite view of the preceding postcard. South Mill Street residential neighborhoods were alongside the Rosena Furnace and other industries. The Shenango Lumber Company was a block away at the corner of White and Neal Streets.

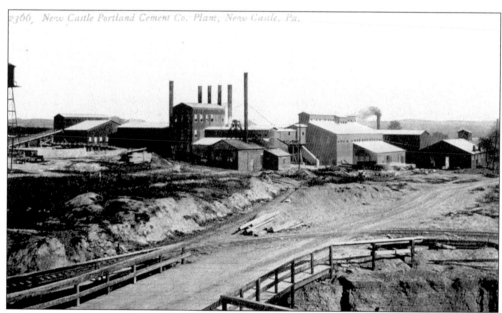

2366 New Castle Portland Cement Co. Plant, New Castle, Pa.

NEW CASTLE PORTLAND CEMENT COMPANY, c. 1909. When U.S. Steel acquired the tin mills from George M. Greer, Greer opened the New Castle Portland Cement Company on North Cascade Street. The company produced brick, clay, limestone, concrete, and ballast. Greer was an enterprising man. He first raised short-horn cattle, then ran a piano and organ store in downtown New Castle. The tin mills came next, and then the cement plant. As a benefactor, he funded the purchase of the Scottish Rite Cathedral's pipe organ.

Seven

LEISURE

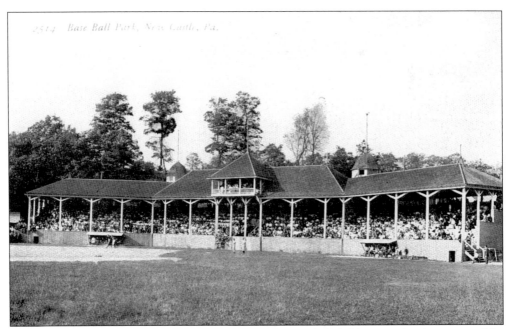

CASCADE BASEBALL PARK, C. 1910. The Cascade Park ball field was said to have one of the deepest center fields in the United States, and only three players ever hit a ball over the fence. When Evangelist Billy Sunday, a former major league player, came to town in 1910 for a crusade, he organized a game between ministers and laymen at this Cascade Park field. He got one hit and stole two bases.

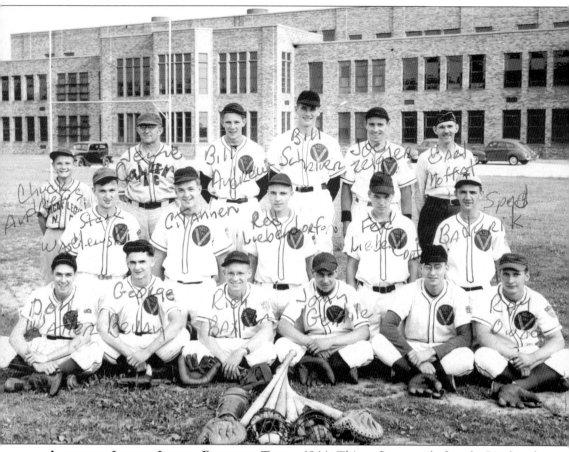

AMERICAN LEGION JUNIOR BASEBALL TEAM, 1944. Thirty-five years before the Pittsburgh Pirates won their fifth World Series under Chuck Tanner's management, Tanner was playing ball with this team. In fact, he hit four doubles in his first game with the team. Tanner is in the middle row, second from left. The team was sponsored by New Castle's Perry S. Gaston Post No. 343. Earl Moffatt, chairman, can be seen in the back row, far right. The school in the background is George Washington Junior High. (Courtesy of Tom Weller.)

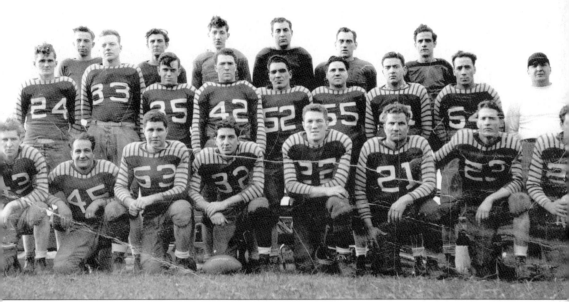

WABASH BEARS, EARLY 1940s. The Wabash Bears were a semi-professional football team in Mahoningtown. They played Ellwood City, Mars, Alliance, and other teams in western Pennsylvania and eastern Ohio. The team practiced at P&LE Field on Wayne Street, but their Thanksgiving Day games, some of them legendary, were in Taggart Stadium. Willie Domenick was the manager and Charles "Tip" Richards was coach (second row, right, in the white shirt). In later years, baseball teams and bowling leagues also carried the Wabash Bears name. (Courtesy of Willie Domenick.)

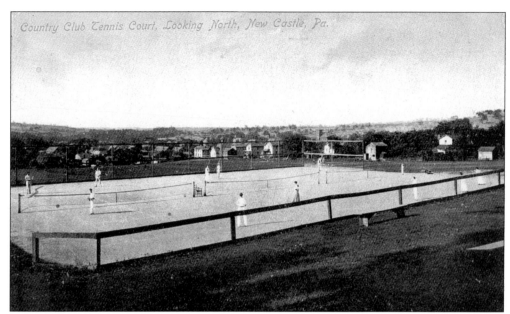

NEW CASTLE COUNTRY CLUB, 1911. As the number of mills and factories grew, busy industrialists needed a place to relax. In 1905, a country club with a golf course, tennis courts, and a gun club was established in the Croton area on the west side of Vine Street. In 1923, the New Castle Field Club opened in Neshannock Township and incorporated the Country Club. In 1943, the Field Club changed its name to New Castle Country Club.

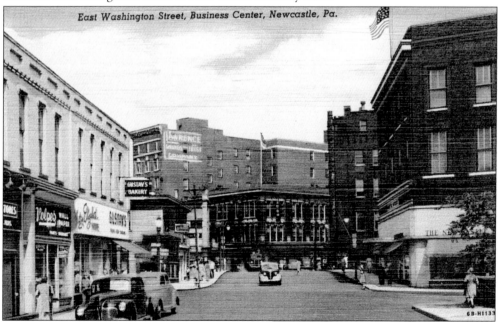

SHOPPING ON EAST WASHINGTON STREET, 1940S. New Castle had several department stores in the 1940s, J. C. Penney, Strouss-Hirshberg, and the one pictured here on the right, New Castle Dry Goods. Penney's had overhead trolleys that zipped money for purchases to a cashier. The Dry Goods used pneumatic tubes. Shopping hours expanded over time, stores remained open on Monday and Thursday evenings.

YOUNG WOMAN AT A LAKE, C. 1924.
Honeymoons and vacations were often
spent along Lake Erie, which was easy to
reach by train. The young woman posed for
this picture postcard on the lake in Lorain,
Ohio, which was near the B&O Railroad
line, but the picture could also have been
taken at Chippewa Lake, Ohio, or Presque
Isle in Erie, Pennsylvania.

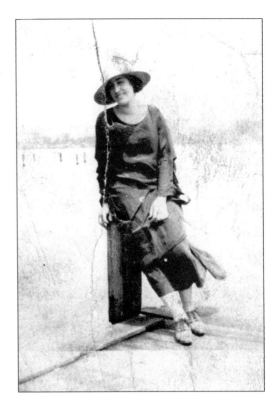

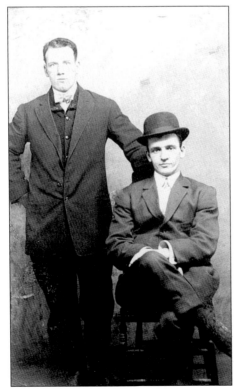

YOUNG GENTLEMEN, C. 1915. The photograph
on this postcard was taken by the Western
Photo Gallery on South Cochran Way near the
Diamond. These two young men may have been
enjoying a day off and decided to let friends and
family know they were doing well.

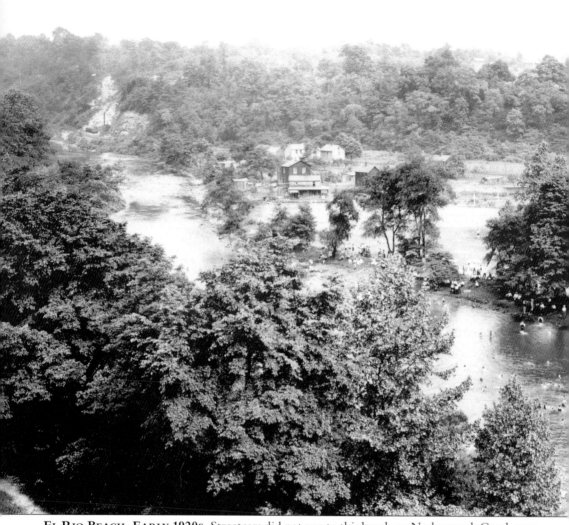

EL RIO BEACH, EARLY 1920S. Streetcars did not run to this beach on Neshannock Creek near the paper mill. It could be reached from Cascade Street downhill toward the creek, or from the bottom of Neshannock Avenue hill. The beach was a favorite place for picnics, dances, roller

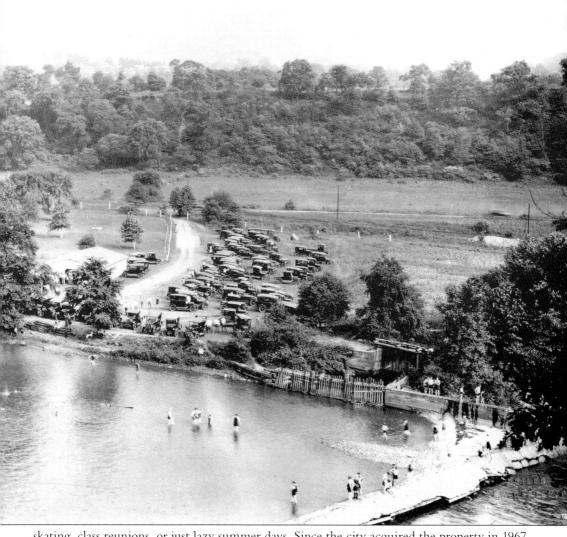

skating, class reunions, or just lazy summer days. Since the city acquired the property in 1967 from owner Erminio Casacchia, the dance hall and other buildings have disappeared, but the good times still echo along the creek. (Courtesy of New Castle Public Library.)

ELKS HOME, 1910. The Benevolent and Protective Order of the Elks (BPOE) is a fraternal organization. The New Castle BPOE Lodge No. 69 was established in 1887, with 40 men as charter members. It was one of the first 100 Elks Lodges organized in the country. The home site was in downtown New Castle at the southwest corner of Falls and North Mill Streets.

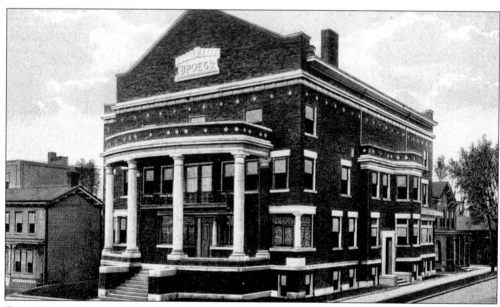

ELKS HOME, EARLY 1920s. Local architect Frank Foulke designed the new Elks Home for the same site as the first building. It was dedicated in 1916. The new building was admired for its distinctive appearance. The lodge moved to South Cascade Street in the 1980s, and the home was sold in 1990. After several owners, the future of this impressive downtown building is in the hands of city officials.

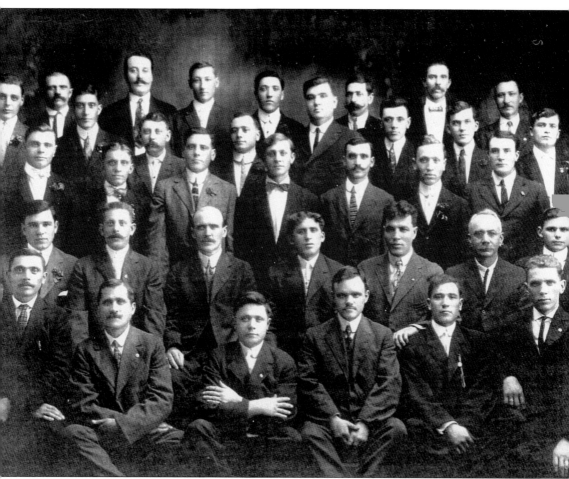

EINTRACHT SINGING SOCIETY, 1915. In 1894, a small group of German and Saxon immigrants began an organization dedicated to singing and hospitality. By 1924, the organization had merged with other German societies and acquired Germania Hall on Taylor Street, its present premises. The society also owns picnic grounds along the Neshannock Creek. Today, the Mannerchor has 28 members, rehearses weekly, and performs regularly. Several members of the Binder and Bodendorfer families are in this photograph. (Courtesy of Eintracht Singing Society.)

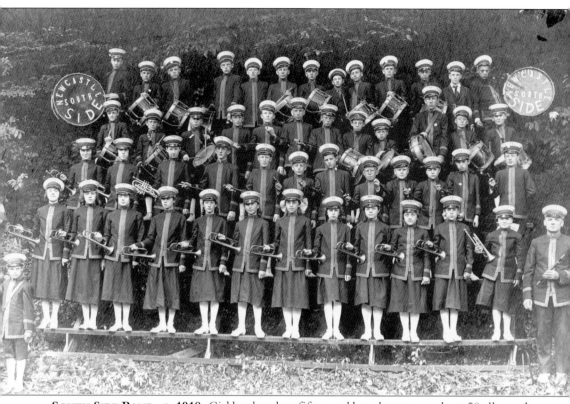

SOUTH SIDE BAND, *C.* 1918. Girl buglers, boy fifers, and boy drummers, about 50 all together, made up this band. Francis Frye organized and instructed the young people, many of whom were probably students at the Lincoln–Garfield School. A few days after the World War I armistice, Ellwood City celebrated the event with a parade and invited the band to march. The city paid all expenses for the young musicians to travel from New Castle, and one merchant donated $8 for ice cream and candy.

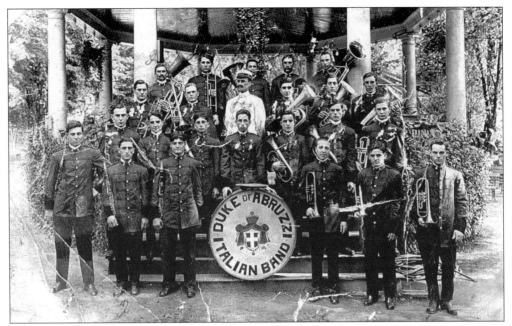

DUKE OF ABRUZZI BAND, C. 1916. This band, posed in the gazebo at Cascade Park, marched in many downtown parades, such as the Mailmen's Parade in 1916 and the New Castle Centennial Parade in 1925. In 1917, at a state fireman's convention, it competed with 14 other bands and won first prize. In the white uniform is Prof. Raffaello Gaspare, director. In the front row, second from the right, is B. J. Biondi, future director of the Red Coat Band. (Courtesy of Michael Colella.)

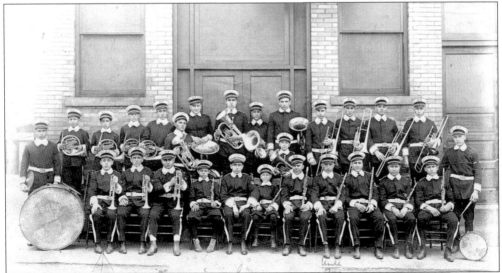

ST. MARGARET'S BAND, C. 1916. Professor Gaspare, who came from Italy as a trained composer and musician, organized bands in both New Castle and Mahoningtown and taught *solfeggio* (do-re-mi sight reading) to many Italian immigrants who wanted to play an instrument. His son Louis (front row, center) directed this band, also known as the Blue Coat Band, in Mahoningtown. Many of these young men, not long from Italy, were already holding jobs with the railroads.

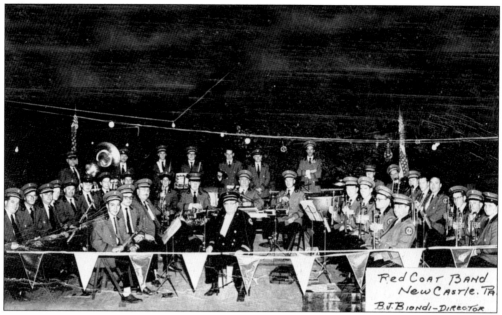

RED COAT BAND, 1950s. B. J. Biondi played the trumpet in this traditional Italian band as a boy and grew up to direct it in 1923 until his death in 1968. He was succeeded by John Bonfield, then Tom Zumpella. The band continues to perform for Italian feast days, as it did in its early days, and it is heard in regular concerts during the summer. (Courtesy of Evelyn Meine.)

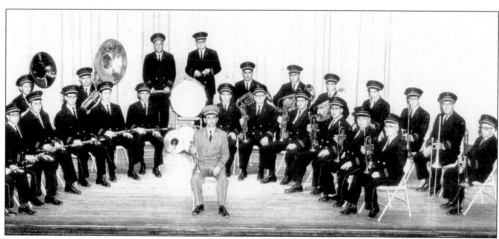

BLUE COAT BAND, 1950s. The director here is Ralph Gaspare II, grandson of Prof. Raffaello Gaspare. Several other members of the Gaspare family are also in the picture. The director of this band today is David Colella, whose father and other family members are in the photograph. Like the Red Coats, this is a traditional Italian band based in Mahoningtown that plays for feasts and community events.

Eight

EVENTS

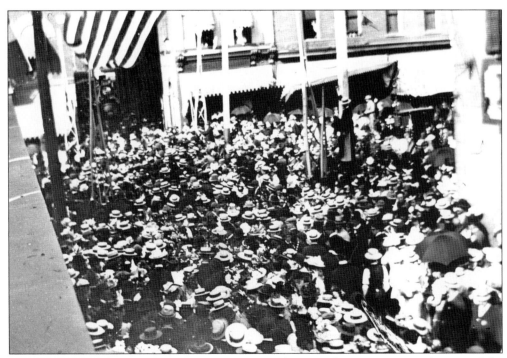

CROWD AT TRAIN IN MAHONINGTOWN, 1898. The Spanish-American War dominated the headlines in 1898. New Castle's citizens rallied as their men went to war. This enthusiastic crowd has gathered on a hot summer day to see the soldiers off at the trains.

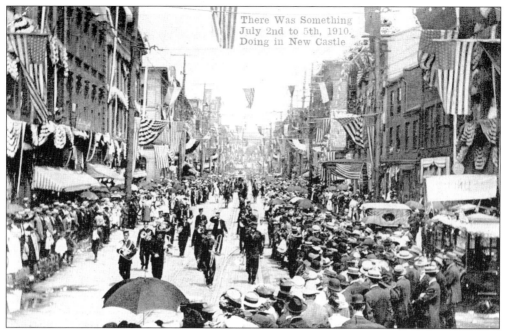

INDEPENDENCE DAY PARADE, 1910. Trains, streetcars, carriages, bicycles, and cars brought 70,000 spectators into New Castle's downtown for the city's four-day Independence Day celebration. The *New Castle News* proclaimed "Monster Parade the Crowning Feature." Bands came from several surrounding towns, and flags, bunting, and fireworks added to the excitement of the event. These marchers are on East Washington Street, approaching the Diamond.

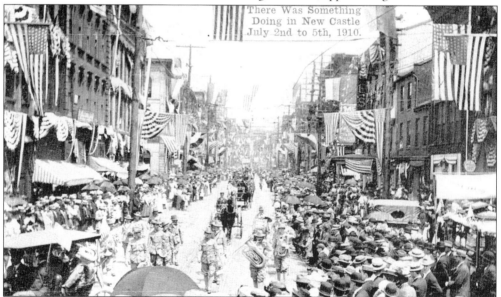

INDEPENDENCE DAY PARADE, 1910. This postcard shows the same day, same place as the preceding postcard, but the band is different. Four days of festivities included a high-wire artist teetering over Neshannock Creek from the Dean Block to the Rohrer store, and another doing a standing slide from the top of a building at Mill and Washington Streets. The *New Castle News* described the celebration as "the gayest, maddest, merriest . . . in local annals."

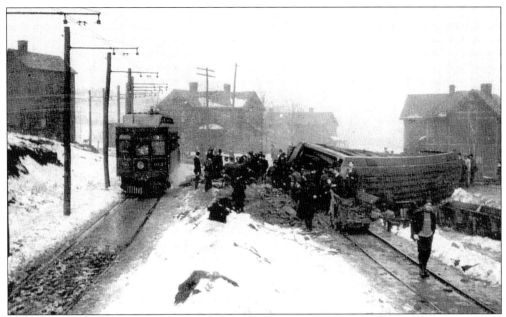

RUNAWAY TRAIN ON HARMONY RAILWAY, 1910. On February 20, 1910, the brakes on this overturned car from the Pittsburgh, Butler, and Harmony Railway failed. It raced down Taylor Street, went off the tracks, and turned over into a gully. Of the 21 passengers, 17 were injured, and one died. The Harmony Railway was a popular rail line between Pittsburgh and New Castle. It stopped running in 1931. (Courtesy of Richard L. Bowker.)

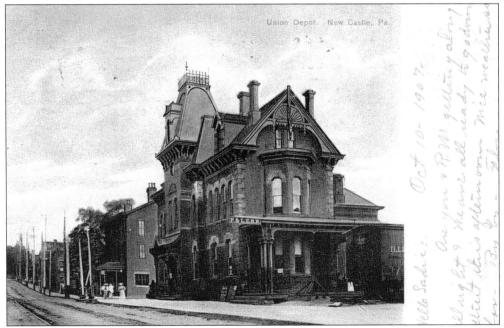

UNION DEPOT, 1907. This classic example of Victorian architecture was on East Washington Street near Grove Street, where Clark's Studio is today. Built in 1901, the depot served passengers riding the Pennsylvania and Pittsburgh & Lake Erie Railroad, as well as other rail lines. The building burned down in December 1910 in below-zero weather.

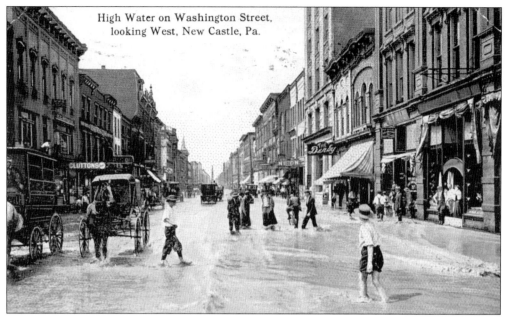

High Water on Washington Street,
looking West, New Castle, Pa.

FLOOD OF 1913, EAST WASHINGTON STREET LOOKING WEST. The rains came on Easter Monday, March 24. Because East Washington Street was situated between the Neshannock Creek and the Shenango River, the high waters moved rapidly into the center of the business district. Here, looking west, the water is right in front of the city hall. The postcard photographers worked fast: the postmark on this postcard is April 29, 1913, just a month after the flood.

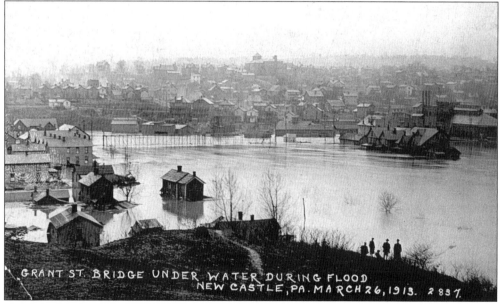

GRANT ST. BRIDGE UNDER WATER DURING FLOOD
NEW CASTLE, PA. MARCH 26, 1913. 2837.

FLOOD OF 1913, GRANT STREET BRIDGE UNDER WATER. By the third day of the flood, the Grant Street Bridge and surrounding houses had been deluged and were disappearing from view. Farther downstream, the rising water threatened the West Washington Street Bridge, the Old Black Bridge, and the Franklin Railroad Bridge. This postcard looks toward the west side of New Castle.

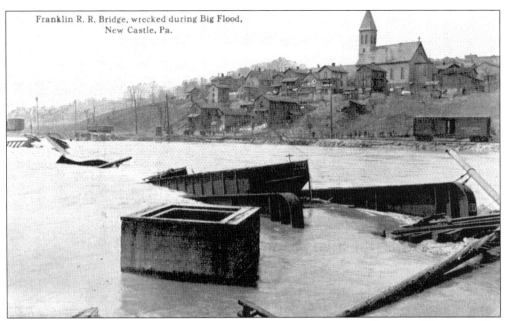

Franklin R. R. Bridge, wrecked during Big Flood, New Castle, Pa.

FLOOD OF 1913, FRANKLIN RAILROAD BRIDGE AND SHENANGO RIVER. This view of the flood looks west. Madonna Church and the houses around it are on higher ground, so they remain untouched by the deluge. The Franklin Bridge was not rebuilt. The Shenango created more wreckage as it joined the Mahoning River in Mahoningtown. There the high water immobilized Lawrence Junction and displaced residents of the Kilkenny neighborhoods.

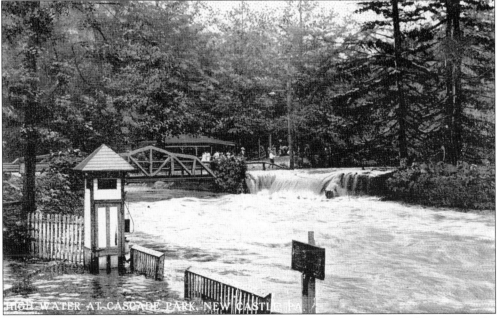

HIGH WATER AT CASCADE PARK, NEW CASTLE, PA.

FLOOD OF 1913, CASCADE PARK. The water in Big Run was high, just as the water in the Neshannock and Shenango was. As can be seen in this postcard, the water rose close to the bottom of many of the park's bridges and rushed into the lake and picnic grove. If any Easter egg hunts had been scheduled for Easter Monday, they would have been cancelled.

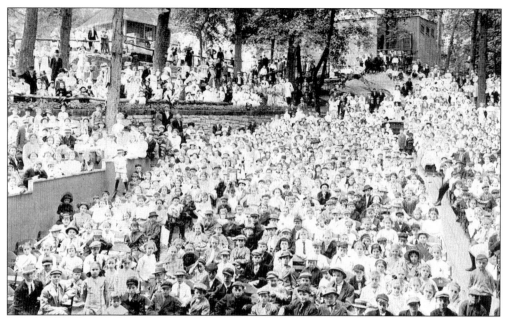

PUBLIC SCHOOL PICNIC, CASCADE PARK. Imagine the excitement when all the schoolchildren got together at once for a picnic at Cascade Park. This postcard shows the children gathered in Cascade Park's open-air theater. Teachers and other adults are in the background. The date is probably early 1900s.

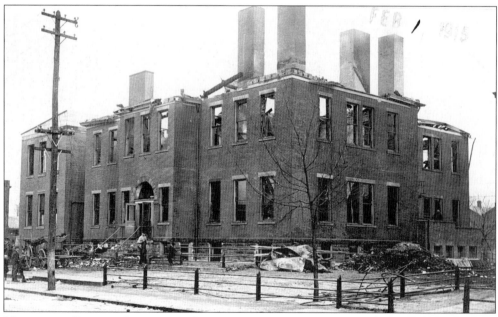

MAHONING SCHOOL AFTER THE BIG FIRE, 1915. Just two years after the flood displaced Mahoning School students from their homes, fire displaced them from their classrooms. The school, built in 1893, burned down in January 1915. This postcard view was taken shortly afterward. Until the school could be rebuilt, students attended classes in makeshift schoolrooms in two local churches.

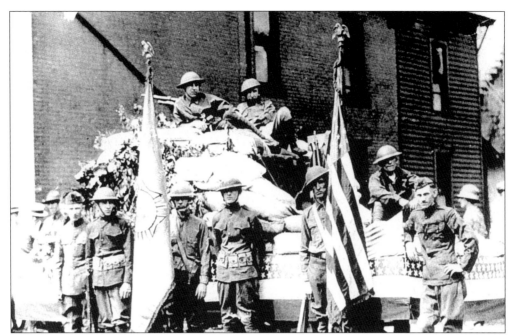

WORLD WAR I VETERANS ON PARADE, EARLY 1920S. Several doughboys in uniform wait for a parade to begin in downtown New Castle. Lawrence County sent 3,200 men to the First World War. Of those, 98 did not return. Armistice Day, Memorial Day, Veterans Day, and Poppy Day paid tribute to the men who served. A bronze plaque on the Diamond remembers them with the poem "In Flanders Fields." (Courtesy of Lawrence County Historical Society.)

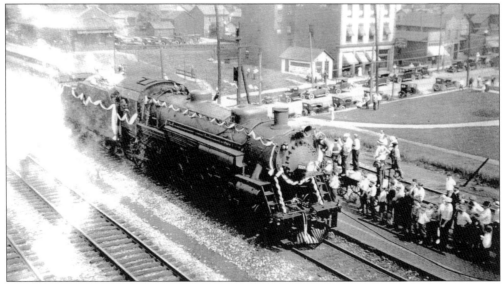

FUNERAL TRAIN OF PRES. WARREN G. HARDING, AUGUST 17, 1923. Pres. Warren G. Harding died on August 2, 1923, in San Francisco. As his funeral train crossed the country to Washington, D.C., the size of the crowds at stations along the way slowed the train. It reached the B&O Station in Mahoningtown on August 17, much later than expected. This photograph shows people gathered to pay tribute to the president. Darlington Park and the Liberty Hotel are in the background.

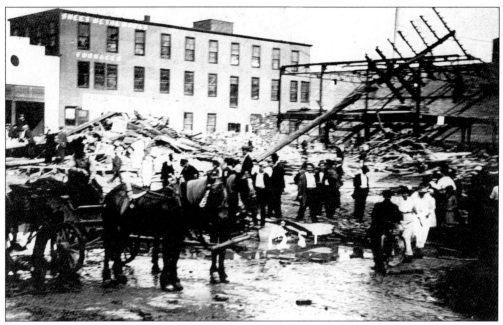

Jameson Fire, July 1921. According to notes on this and a companion postcard, a large fire devastated a neighborhood of houses and businesses in New Castle, as seen here. The *New Castle News* had no account of such a fire. Neither did the New Castle Public Library, the Lawrence County Historical Society, nor the Ellwood City Historical Society. If any reader can identify this card, please notify the author.

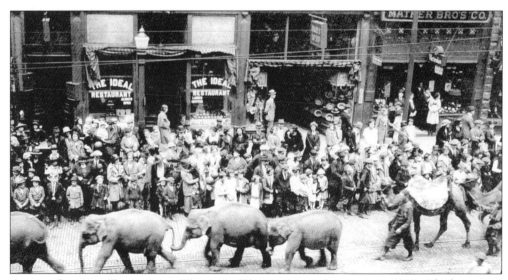

Circus Parade Traveling West on Washington Street, c. 1923. Elephants and camels on the streets of New Castle; what a treat for children and grownups alike! This is the north side of East Washington Street between Mill and East Streets. The Ideal Restaurant in the background had an ideal location: it was handy for customers of the Nixon Theater (not in the picture, but a few doors to the right).

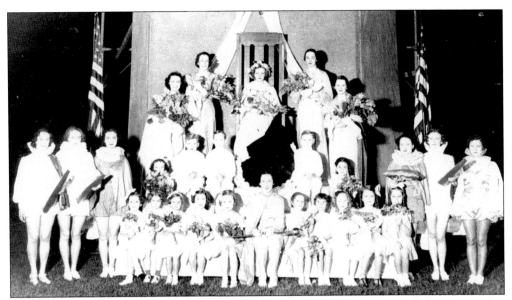

MAY QUEEN CROWNING, 1937. Seven hundred boys and girls were in the ceremony that crowned New Castle's May Queen in 1937. The event started with a parade marching from the American Legion Home downtown to Taggart Stadium on the East Side. At the stadium, there were drills, band music, choruses, and fireworks. Here, the most popular girl of New Castle High School's senior class, Janet Hartland, and her court pose after the pageantry. The event raised money for uniforms and instruments for school bands. (Courtesy of Jack Thompson.)

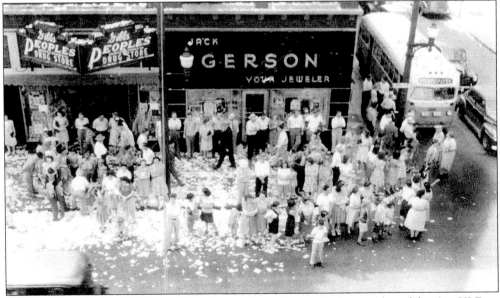

DOWNTOWN AFTER VJ DAY, 1945. Crowds have dispersed after parades celebrating VJ Day. At East Washington and Mill Streets, Gibbs Drug Store was a favorite hangout for high school students, the back booths for the girls, and the front sidewalk for the young men to watch the girls go by. The Jack Gerson jewelry store was famous for its mechanized window displays. Today, these storefronts are being rehabilitated for entertainment and retail use. (Courtesy of Lawrence County Historical Society.)

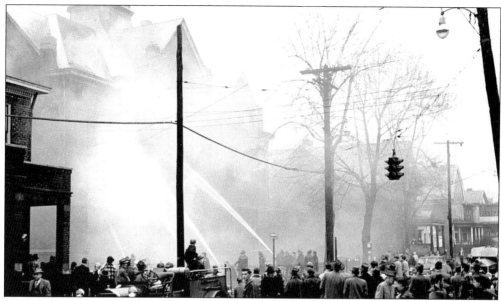

NORTH STREET SCHOOL FIRE, 1952. Until New Castle High School was built in 1911, the North Street School was the city's high school. Centrally located at the corner of North and East Streets, it was then an elementary school until this fire in February 1952. A new building housed school administration offices and Universal Rundle offices, and currently, Sky Bank offices. (Courtesy of Lawrence County Historical Society.)

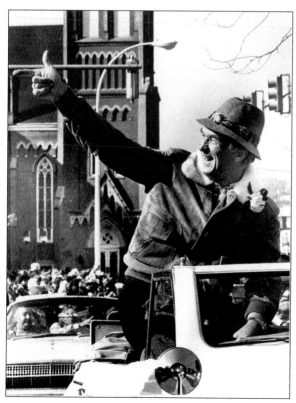

PARADE HONORING CHUCK TANNER, 1979. Chuck Tanner was manager of the Pittsburgh Pirates baseball team in 1979, when the Pirates won the World Series championship. New Castle's mayor Francis Rogan and more than 50,000 New Castle residents turned out to cheer for Tanner. Before the series victory, Tanner had already had a distinguished career as a player and as a manager. In his very first at-bat, as a pinch-hitter for the Milwaukee Braves, he hit a home run. He was the American League's Manager of the Year in 1972. (Courtesy of Chuck Tanner's Restaurant.)

Nine

CASCADE PARK

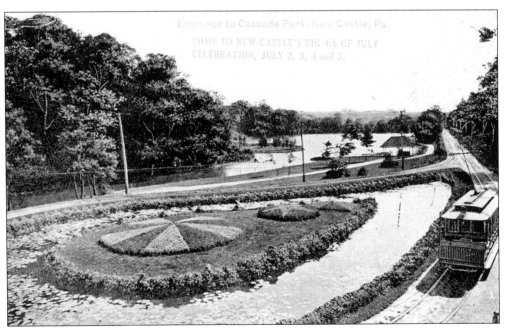

ENTRANCE TO CASCADE PARK. Cascade Park is on land that was once called Big Run Falls, named for Big Run that flows through it. In 1891, Col. Levi C. Brinton bought 70 acres and promoted it as Brinton Park. The New Castle Traction Company then bought the park from Brinton and opened it in 1897 as Cascade Park. In 1934, the ownership of the park, which had been enlarged by then, was transferred to the City of New Castle for $1.

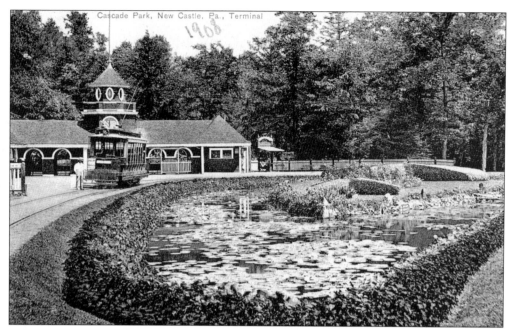

Cascade Park, New Castle, Pa., Terminal
1908

STREETCAR TERMINAL AT CASCADE PARK. Streetcars to the park traveled up Hamilton Street from New Castle's South Side. At the terminal, the streetcar tracks looped around a beautifully landscaped lagoon, and waiting passengers could enjoy the scenery and nearby lake. Today, the main entrance to the park is on East Washington Street, and this area of the park is considered the back entrance.

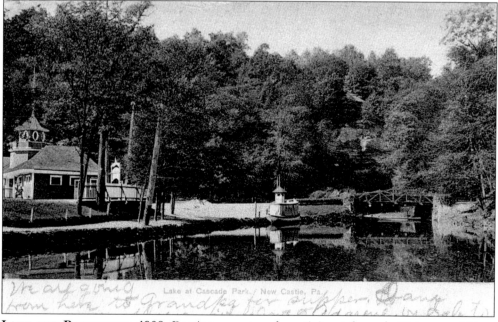

Lake at Cascade Park, New Castle, Pa.

LAKE AND BOATHOUSE, 1908. Boating was a popular activity at the park. Visitors could hop off the streetcar at the terminal (here, behind the boathouse) and head for the boats. This boat is powered by steam. A rustic bridge and the Cat Rocks are to the right. On holidays or other special occasions, fireworks would be set off from a little island across from the boathouse.

100

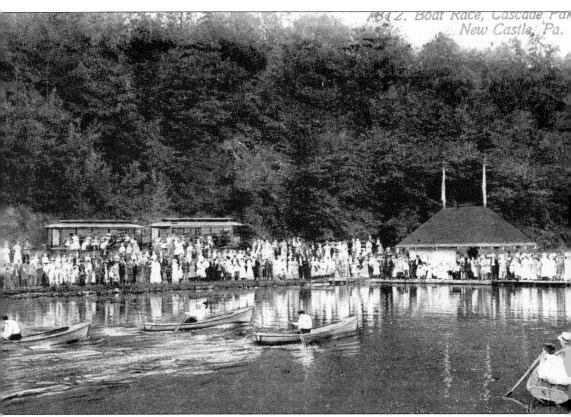

BOAT RACE ON THE LAKE, 1912. Crowds of this size regularly visited Cascade Park. The picnic grove near the lake was said to accommodate 2,000 picnickers, and a tourist camp with cooking facilities was available to travelers. Over the years, the 15-acre lake filled with silt. Dredging was needed if water was to flow again. In the 1950s, local citizen and benefactor Jack Gerson was able to muster support and the lake was dredged and refilled. Since the dam broke in 1981, the silt has again taken over.

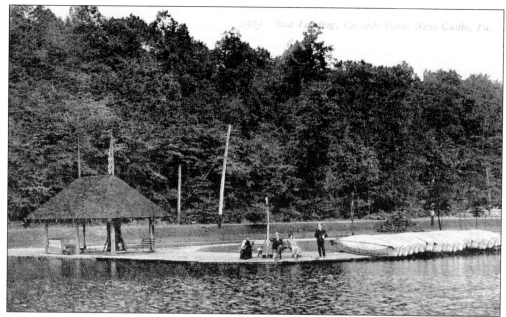

ROWBOAT RENTAL, 1911. In this postcard, rowboats are lined up for rental. Visitors could rent rowboats for 35¢ an hour. The boats were numbered so they could be called in on a loudspeaker when the hour was up. If the boat did not come in, a boat chaser would row out and ask the party to come in. Parties who refused ran the risk of being dunked.

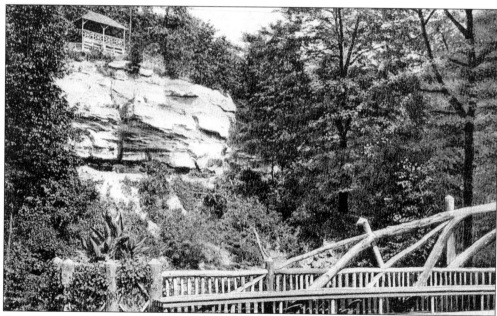

CAT ROCKS, 1908. The origin of the name for these rocks is not known, although one can imagine a cat ready to pounce from their height. The rocks afforded a view of the rustic bridge made of bent tree limbs and the lake beyond it. Such a view could not take it all in: baseball field, swimming pool, roller coaster, summer cabins, petting zoo, rides, arcade, dance pavilion—the park had it all.

Bathing Scene, Cascade Park, New Castle, Pa.

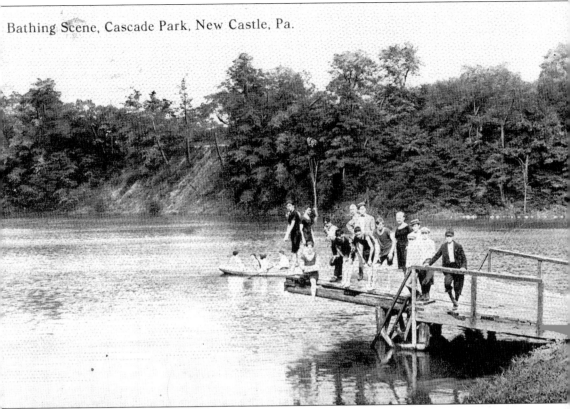

BATHING SCENE, 1912. The sender of this card must have meant to tease the recipient. He mailed it in February 1913 and asked about the weather in Ohio. Swimming was a major summer activity at Cascade Park. At first, this simple wooden structure served the swimmers. Eventually Billy Glenn, famous for his peanuts and popcorn, removed the zoo and its animals, and installed a pool and bathhouse. In 1975, after much remodeling, the park finally got an Olympic-sized swimming pool. The maintenance and management of the pool eventually was shared by the city and the Community Y, but the pool was closed in the 1990s. It is no longer there.

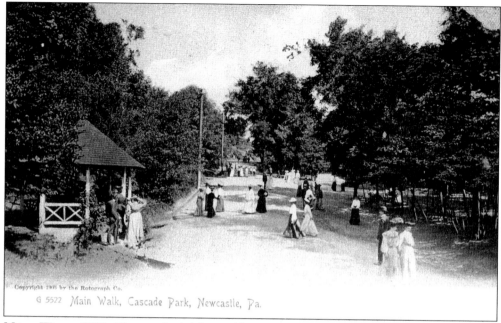

MAIN WALK, 1908. The terminal, lake, and boats were at the lower part of the park. So was a shady picnic grove. Visitors would take this main walk up to the amusements, arcade, and dance pavilion. On the way, they would pass some gazebos. One offered natural spring water through a carefully built rock fountain. Another was for band concerts.

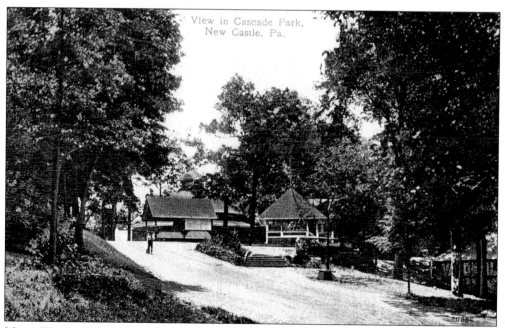

MAIN WALK, 1921. This walk uphill led to the carousel, dodg'm cars, roller coaster, seaplanes, and dance pavilion. The carousel was replaced in 1922, then again in the 1950s. In 1924 and 1925, the Fun House and Old Mill were installed to the right of this walk. The Fun House replaced part of the theater, and the Old Mill replaced a saw mill that had been powered by the dam.

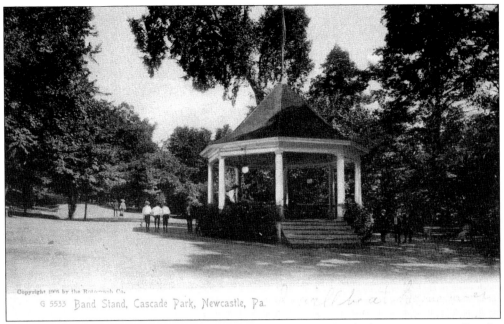

Copyright 1906 by the Rotograph Co.
G 5533 Band Stand, Cascade Park, Newcastle, Pa.

BAND GAZEBO, 1907. The gentle slopes of the hills and the shady trees were perfect for concerts on hot summer days. Events like Old Timers' Day, school picnics, company picnics, and national holidays would be occasions for a concert. The open-air theater nearby provided seats for vaudeville shows and other entertainments.

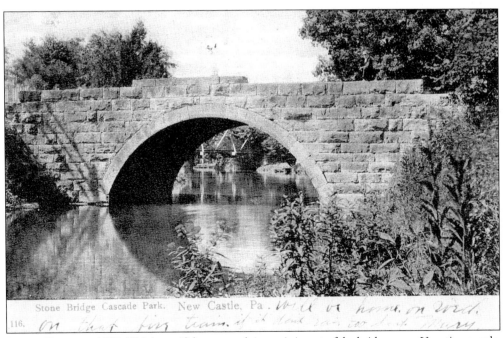

Stone Bridge Cascade Park. New Castle, Pa.

STONE BRIDGE, 1907. This beautiful stonework is reminiscent of the bridges over Venetian canals. The bridge was near the East Washington Street entrance to the park, where remnants of the structure can still be seen. The rustic bridge that can be seen under the arch leads to the falls.

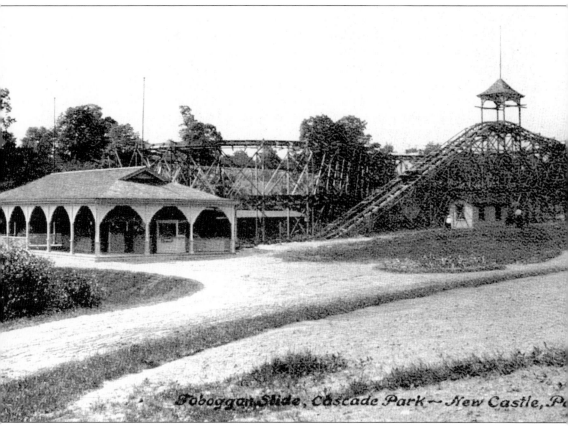

Toboggan Slide, Cascade Park ~ New Castle, Pa

ROLLER COASTER, 1911. A few years after Cascade Park opened, this roller coaster was installed. It was probably built by the Philadelphia Toboggan Company, the oldest roller coaster company still in operation today. In 1922, Billy Glenn, most remembered for his popcorn wagon, asked the same company to build a new roller coaster for the park, called the Gorge. Glenn, who had installed other rides and attractions at the park, lived with his family in a house under the roller coaster. The Gorge, the most popular ride at the park, was succeeded in later years by the Comet, installed in the 1950s by Paul Vesco.

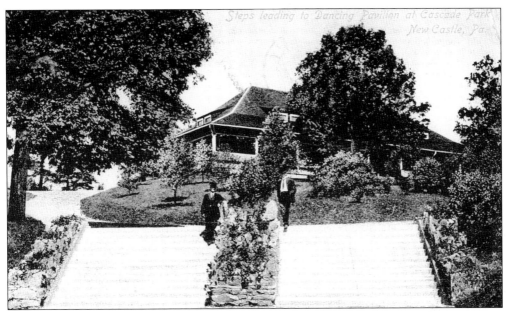

FLORAL STEPS AND DANCING PAVILION, 1911. Frank Blaisdell was the Boston landscape designer hired to turn New Castle Traction Company Park into Cascade Park. Using the topography and natural beauty of the park, he created the lake and dam and then installed flower beds throughout the park. Orange nasturtiums were everywhere. Here, a graceful flight of stairs takes visitors to the dance pavilion.

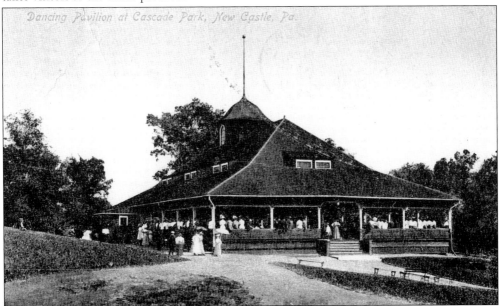

DANCING PAVILION, 1911. The open-air dance pavilion was said to be the largest in Pennsylvania. Over the years, the ballroom was the place to dance to the music of Paul Whiteman, Jack Shepp, Johnny Dachko, and Frances Hammond's Keystone Serenaders. It became Swing Lobby for teenagers in the late 1940s. In the 1970s, after years of deterioration, a local square dance group, the Paws 'n Taws, restored the building. The ballroom still swings with music for dancing on Saturday nights in the summertime.

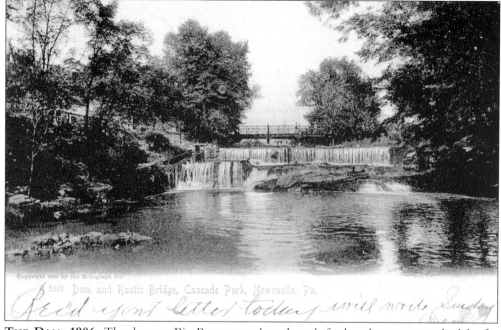

Copyright 1906 by the Rotograph Co.

5521 Dam and Rustic Bridge, Cascade Park, Newcastle, Pa.

Rec'd your letter today, will write Sunday

THE DAM, 1906. The dam on Big Run created pools and, farther downstream, the lake for boating and fishing. Big Run flowed south to join the Shenango River. Scenes like this provided welcome relief in the heat of summer. The young people may have preferred the rides and other amusements, but adults welcomed the beautiful views. Of course, everybody liked the peanuts and popcorn.

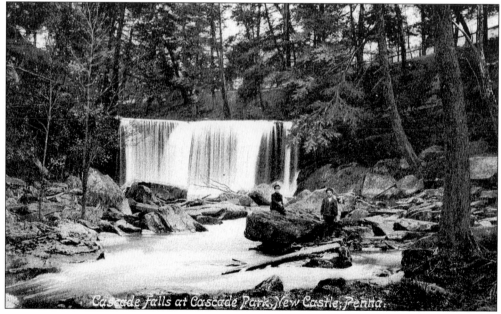

Cascade Falls at Cascade Park, New Castle, Penna.

CASCADE FALLS NEAR THE DAM, 1909. Before there was a park, nearby farmers would wash their sheep under these falls. Later, when a local newspaper ran a contest to name the park, Edwina Norris, a 10-year-old girl, submitted the name "Cascade Park." She was inspired by the cascades in Big Run as it ran through the park. She won $10 and a place in New Castle history.

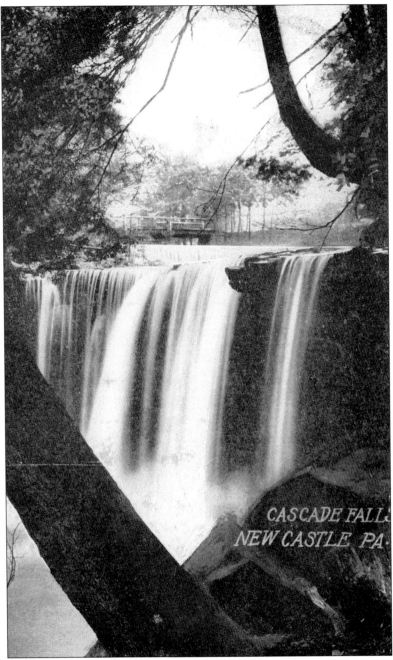

THE CASCADE FROM THE RAVINE, 1911. Starting in 1899, excursion agents were available for the many out-of-towners who booked excursions to see the falls. Companies like H. J. Heinz in Pittsburgh scheduled regular outings there. Fifteen trolleys an hour could make the trip from downtown New Castle, with the capacity of 7,200 passengers. Considered a "trolley park" because it was owned by the traction company and promoted their business, the park outdid the competition. There were two other trolley parks in the area, Idora Park in Youngstown, Ohio, and Kennywood Park in Pittsburgh, but neither had the natural beauty of Cascade Park, which had grown to 82 acres.

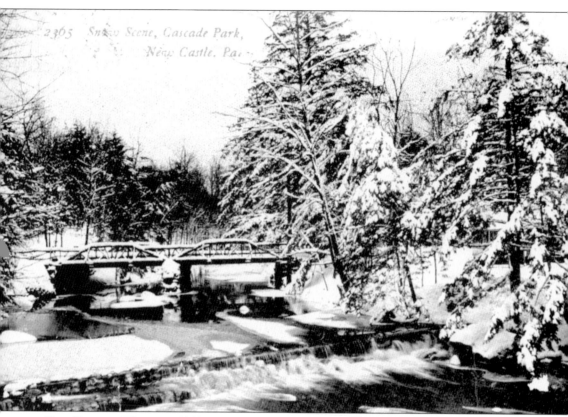

THE PARK IN WINTER, 1912. How many of the park's visitors have seen a winter wonderland like this? In recent winters, the city has provided lighted holiday displays throughout the park. The colorful figures and setting are yet another way to enjoy a visit. The park had little competition in the years it thrived. Even without all the rides and entertainment, this remarkable place continues to provide beauty and pleasure to all who visit.

Ten

MAHONINGTOWN

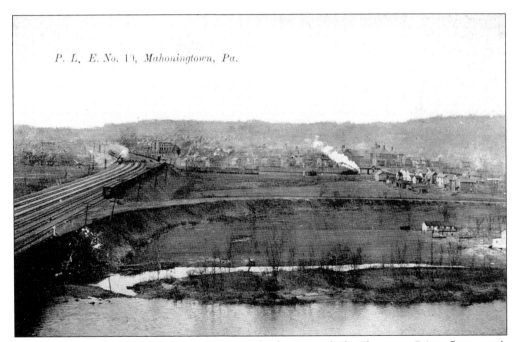

P. L. E. No. 19, Mahoningtown, Pa.

BIRD'S-EYE VIEW OF MAHONINGTOWN. In the foreground, the Shenango River flows south from New Castle. A Pennsylvania Railroad train runs across the center. Tracks on the left are the Baltimore & Ohio and the Pennsylvania & Lake Erie Railroads, built on the site of the old Cross-Cut Canal. Mahoningtown's railroads brought commerce, their repair shops provided employment, and their free passes broadened the perspective of workers' families who could travel to other cities and towns.

MAIN STREET LANDMARKS, 1920s. At the center is North Liberty Street, the main street. Center right is the B&O and P&LE railroad station. Behind the station is the Arlington Hotel (right). Walkways lead to the New Castle streetcar line. Darlington Park is in the foreground. The Liberty Hotel is at center right. Continuing to the right would be shops and other businesses.

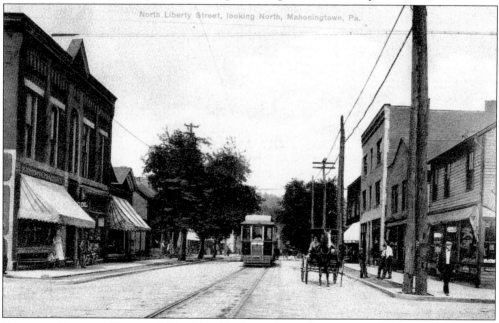

BUSINESS CENTER, EARLY 1900s. Two blocks up from the station, North Liberty Street was lined with a post office, drug stores, clothing stores, a millinery, grocery stores, a pool hall, and other businesses. In this picture, showing the street at Wabash Avenue, the streetcar is headed south to the end of the line at the station. Going the other way, the streetcars ran "uptown" to New Castle.

EARLY VIEW OF NORTH LIBERTY STREET, EARLY 1900s. Residents of Mahoningtown did not have to go uptown for much business. This view of Liberty Street is at the corner of Wabash Avenue looking north. Macmillan's Mahoningtown Pharmacy is on the left. The building next to it offers billiards. In the next block is the J. C. Norris grocery and dry goods store. On the right is Hamilton's tobacco and confectionery store, and Wabash Avenue on the right leads to George Meyer's hardware store.

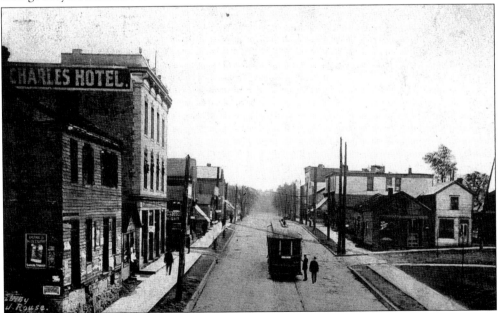

END OF THE STREETCAR LINE. Streetcars began running in Mahoningtown in 1898. In this postcard, the streetcar conductor changes the streetcar's direction. He adjusts the overhead trolley and moves the backs of the wicker seats so passengers would face north. The hotel in this older view was the Charles Hotel, to be renamed the Liberty Hotel later. Darlington Avenue and Darlington Park are on the right.

DARLINGTON PARK BEFORE IMPROVEMENTS. This postcard is undated, but it appears to be what the park was like before walks were cut and flowers and trees were planted. The park was named for Benjamin Darlington, who, with William Hayes, laid out Mahoningtown in 1836 from a 500-acre tract they owned. Darlington Avenue runs on the north side of the park and the B&O and P&LE are on the south side.

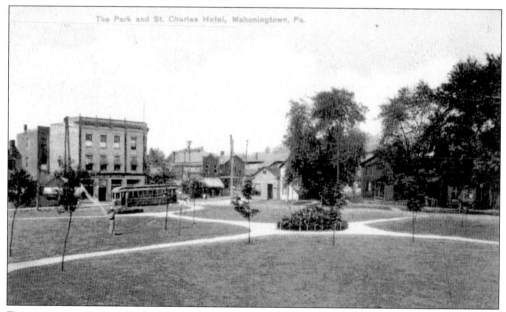

DARLINGTON PARK, 1912. The park was where people gathered for concerts and other civic events in spite of the loud trains running next to the park. In the 1930s, championship boxing matches were broadcast on loudspeakers and concerts were regular events. Today, it is where residents celebrate the annual Community Day with music, dancing, a church service, reunions, exhibits, nostalgia, and good food. There is still noise from the trains on the south side of the park, but today it is the CSX railroad.

114

FIRE HOUSE, EARLY 1900s. The fire station was in the center of town at the southwest corner of East Cherry and North Cedar Streets. Across Cherry Street was Mahoningtown's city hall, where the borough council once met. Mahoning School was in the next block, but the fire department could not save the school in 1915 when it burned down. A four-alarm fire at the American Box Factory, also on North Cedar Street, was described as "spectacular."

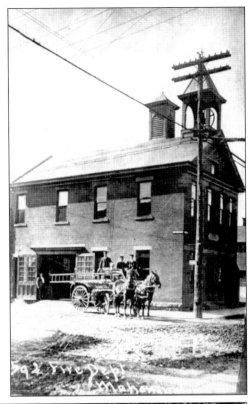

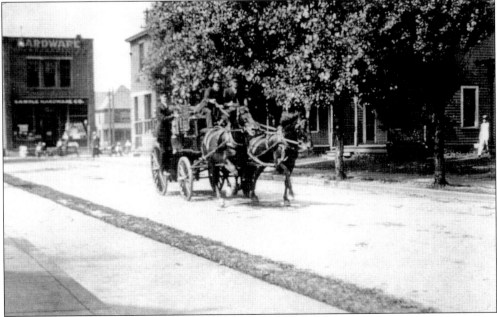

FIRE CALL ON CEDAR STREET, EARLY 1900s. Mahoningtown's firemen will pass the Presbyterian Church and Mahoning School as they make their way to the fire call. In the background, the store on the corner is Sample's Hardware on Cherry Street. Mahoningtown was compact, with most goods and services in walking distance.

POST OFFICE, NORTH LIBERTY STREET, EARLY 1920s. Postmaster Ed McBride is seated in the center of this photograph. Because Mahoningtown was often called "Cross-Cut Village" after the name of the canal, the post office was once called the "Cross-Cut Post Office." The town was annexed to New Castle in 1898, and it continued to have its own post office until 2003. (Courtesy of John Hitch.)

SAGER MILLINERY ADVERTISING CARD, 1913. The printed notice on the back of this card reads "Mrs. G. W. Sager announces to the Ladies of Mahoningtown and vicinity her Fall Opening of Up-to-Date Millinery for Monday, Tuesday and Wednesday, September 15th, 16th and 17th, 1913." This shop was located between Cherry Street and Wabash Avenue near Hyde's Drug Store, which opened in 1895.

GEORGE MEYER'S HARDWARE STORE, 1920s. This hardware store has a long history. It was on East Wabash Avenue in the early 1900s, then, around 1913, it moved to East Cherry Street where this photograph was taken. By 1923, the store was located at the northeast corner of Liberty and Cherry Streets. In 1937, when it moved to its present address at 207 North Liberty Street, the name changed to Meyer and Weller and then to Paul D. Weller Hardware. One of Paul Weller's grandsons, Tom Weller, operates the store today. Paul Weller is standing farthest back, next to the gentleman with the white hair. (Courtesy of Tom Weller.)

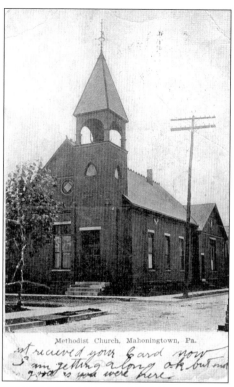

Methodist Church, Mahoningtown, Pa.

st received your Card now I am getting along ok but no good is you were here

MAHONING METHODIST CHURCH, EARLY 1900s. The Methodists in Mahoningtown built three churches, all on the same site: the northwest corner of North Cedar Street and East Madison Avenue. The first, a frame building, was built in 1867 when Mahoningtown was known as "the Village of Cross-Cut." That church was used until 1893. The second one, a brick structure, is pictured on this 1909 postcard. It was used from 1893 to 1912.

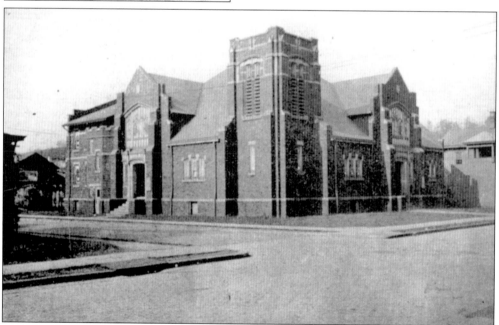

MAHONING METHODIST CHURCH, 1912. The third Methodist church went up on the same site as the second one. Fortunately for the students of Mahoning school, when the school burned down in 1915, some classes could continue in this building which was across the street. The Methodists conducted their last services here in 1992. In 1993, the building was bought by the Church of the Genesis, which is strongly supported in the community.

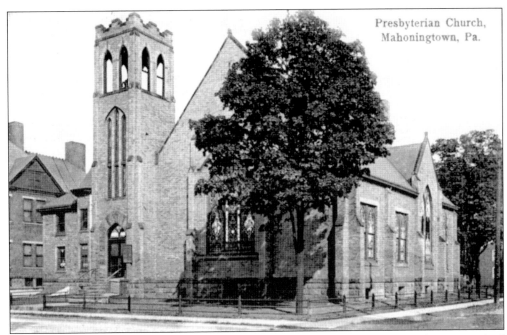

Presbyterian Church, Mahoningtown, Pa.

MAHONINGTOWN PRESBYTERIAN CHURCH. The Mahoning Presbyterian Church was organized in 1866. This building went up in 1901 on the northeast corner of North Cedar and East Cherry Streets. Mahoning School was next door on Cedar Street, so class pictures were often taken on the church steps. The church closed in 1984.

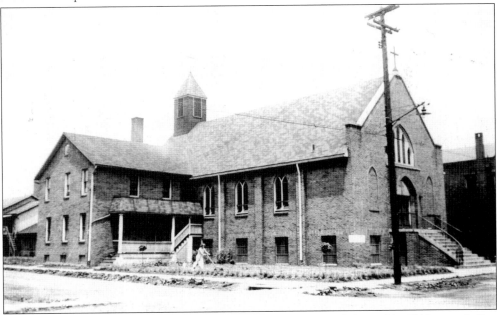

SECOND ST. LUCY'S CHURCH, 1945. The first St. Lucy's was dedicated in 1913 as an Italian ethnic church on South Liberty Street. This second one at North Cedar Street and Wabash Avenue was dedicated in 1931. The third church, on Lucymont Drive near Clayton Street, was dedicated in 1978. In 1993, when several congregations merged to form St. Vincent de Paul parish, St. Lucy was named the parish church. (Courtesy of Diocese of Pittsburgh Archives.)

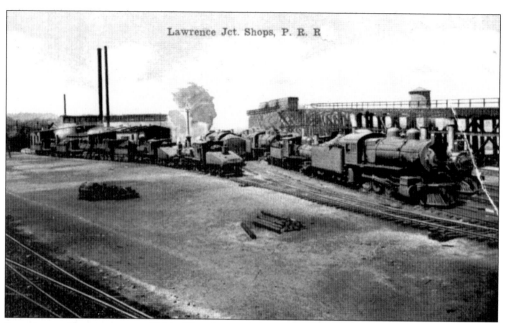

Lawrence Jct. Shops, P. R. R

LAWRENCE JUNCTION, C. 1916. The shops of the Pennsylvania Railroad were located at the south end of Liberty Street. The site was low, situated near the path of the former Cross-Cut Canal, so it was often under water, particularly in the flood of 1913. Pennsylvania stations in Mahoningtown were on East Cherry Street and off Route 18 past the crossing on Montgomery Avenue. The station in New Castle was on West Washington Street near the Diamond.

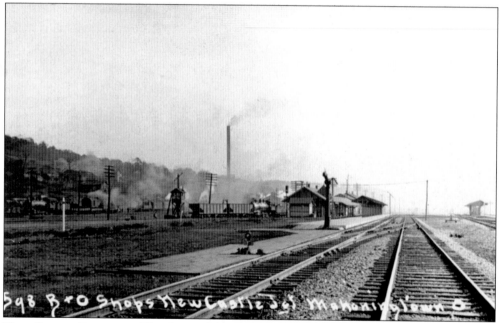

NEW CASTLE JUNCTION. The shops of the Baltimore and Ohio Railroad (B&O) were on the outskirts of Mahoningtown toward the town of West Pittsburg. This was where Pres. Harry Truman took over the diesel engine on the way to Pittsburgh on his whistle-stop tour in the fall of 1948. By coincidence, the last B&O steam locomotive left Baltimore in the fall of 1948.

Scene on the Shenaugo River, Mahoningtown, Pa.

RANEY'S MILL ON THE SHENANGO RIVER, 1910. The large building in these views is a gristmill (flour mill). In 1852, James Raney built Mahoningtown's first flour mill along the Cross-Cut Canal. In 1873, he built the dam that is seen here spanning the Shenango and this new mill that he operated with his son Leander. The capacity of the mill was 100 barrels a day, and the high quality of the flour promoted sales throughout the region. The 1897–1898 city directory shows Raney's business at 322 East Cherry Street. These views are looking northwest across the Pennsylvania Railroad tracks toward "Tube Town."

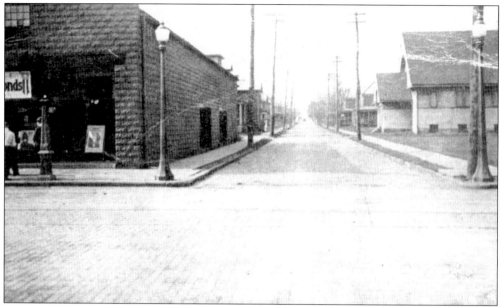

WEST MADISON AVENUE, C. 1918. On the right is Madison Avenue Christian Church, which closed in 2004. On the left is the first Crescent Theater. For many years, this would be the only intersection in Mahoningtown with a traffic light. The note on the back of the postcard reads "Just a line to let you know I am now a resident of Mahoningtown, Pa., have not seen many of the skyscrapers yet."

CRESCENT THEATER, 1926. First called the Mahoning Photoplay Theater, the Crescent opened in 1915 at the southwest corner of Liberty and Madison Avenues. The owners were C. E. McDougal and W. J. Wray. The name changed in the 1920s. Louis Perretta bought the theater in 1935 and remodeled it in 1938. He remodeled it once more in 1941 after a fire. This picture was rescued from that fire. (Courtesy of Norma Perretta.)

CRESCENT THEATER, 1941. Newly rebuilt after the fire, the Crescent Theater reopened on September 17, 1941. The featured film starred Alice Faye, Don Ameche, and Carmen Miranda. Some moviegoers who attended the opening that night missed seeing a spectacular aurora borealis (northern lights), a rare sight in the skies of Mahoningtown. Movies stopped running in 1959, and in 1960, the New Castle Playhouse moved in. The Playhouse moved out in the late 1960s, and the building was demolished in 1975. (Courtesy of Norma Perretta.)

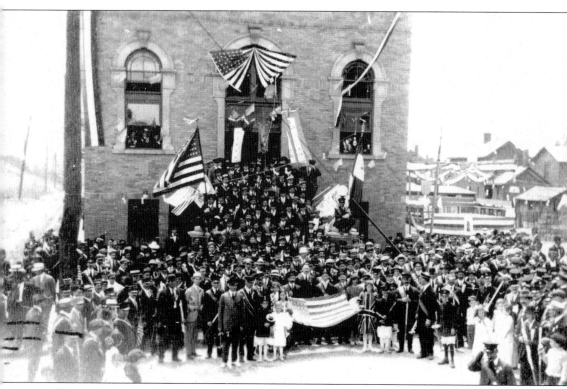

DEDICATION OF CHRISTOPHER COLUMBUS HALL, 1913. Dignitaries, bands, bunting, and enthusiastic supporters made a festive scene the day the Christopher Columbus Society dedicated its building. On the southeast corner of Lacock and Liberty Streets, the hall would be the social center for members of the society. It was the scene of weddings, banquets, Columbus Day celebrations, and saints' day street festivals. Twenty-five years later, more than 400 people attended the anniversary banquet. The building came down in the early 1990s after being closed for many years.

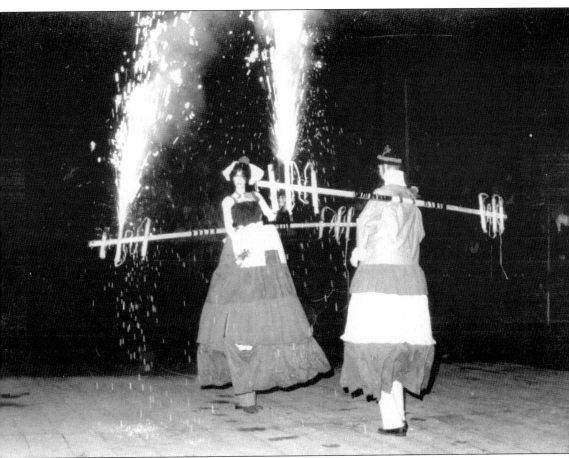

BABY DOLL DANCE. In contrast to the solemnity of the opening of a saint's feast day, the evenings were like street fairs with food, band concerts, confetti, a baby doll dance, and fireworks. Some traditional baby dolls can stand over 10 feet tall. The doll is carried by a dancer who ignites fireworks during the dance, usually a tarantella played by the band. A good deal of craft is required to construct and dress the doll, and a good deal of caution is needed to dance safely. In Mahoningtown, a traditional feast would close with the dance, and then a crowd would march behind the band to the field where music would be played for the fireworks display. (Courtesy of Zambelli Fireworks Internationale.)

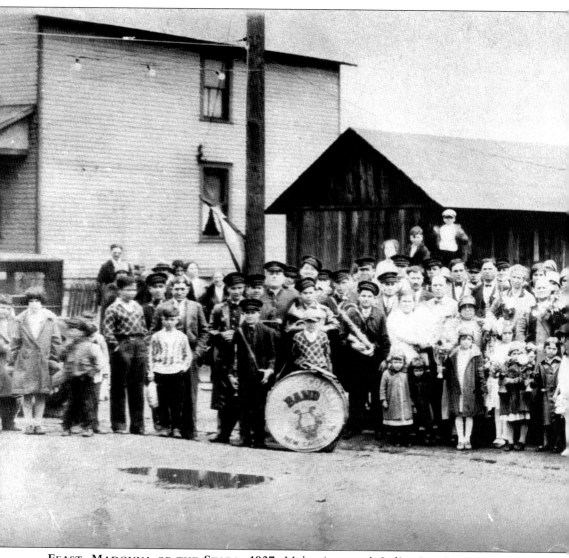

FEAST, MADONNA OF THE STARS, 1927. Mahoningtown's Italian immigrants, now U.S. citizens, continued to honor their patron saints even though they had left their native land. This photograph shows former residents of the town of Riardo, Italy, in front of the first St. Lucy's Church. The photograph would have been taken in the morning, after the mass, in early

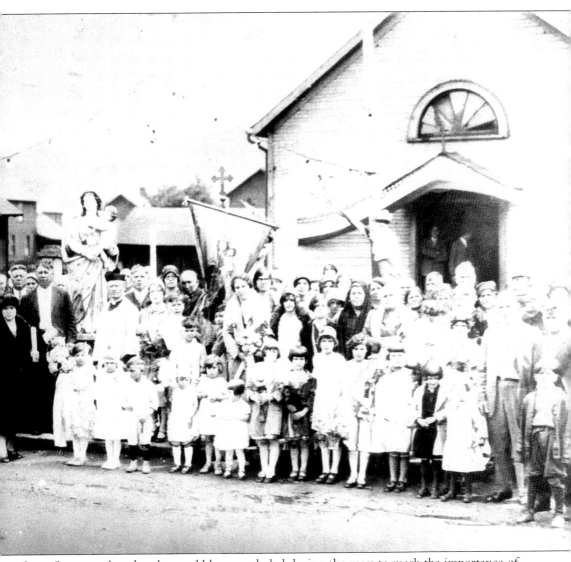

June. Some outdoor bombs would have exploded during the mass to mark the importance of the occasion. There would also have been an outdoor procession of the statue of the Madonna, clergy, children strewing flower petals, a band, and devotees. The day would close with a street festival. This feast day is still observed in Mahoningtown, as it is in Riardo.

BIBLIOGRAPHY

Art Work, Beaver and Lawrence Counties, Pennsylvania. Chicago: W. H. Parish and Company, 1894.

Atlas of the County of Lawrence and the State of Pennsylvania. Philadelphia: G. M. Hopkins and Company, 1872.

Burmester, Bill. *Legends of Lawrence County.* New Castle, PA: New Castle News, 1992.

Durant, S. W. and P. A. *History of Lawrence County, PA*: Philadelphia: L. H. Everts and Company, 1877.

Fox, Donald W., ed. *Bridges to the Past: A Pictorial History of Lawrence County.* New Castle, PA: Lawrence County Historical Society, 1994.

Hazen, Aaron. *20th Century History of New Castle and Lawrence County, Pennsylvania.* Chicago: Richmond-Arnold Publishing Company, 1908.

Jurey, Philomena. *Bella Giornata and Elbow Grease: Remembering Papa and Mama, the Sparanos of New Castle, Pennsylvania.* Washington, D.C.: Linus Press, 2002.

Souvenir Program, New Castle Centennial Celebration, 1825–1925.

Souvenir Program, New Castle Sesquicentennial, 1798–1948.

Weller, Tom. "The History of Mahoningtown, Pennsylvania." Unpublished paper presented at the Lawrence County Historical Society, April 29, 1998.

Wood, Wick W., compiler. *History of Lawrence County.* New Castle, PA: News Company, 1887. Republished by J. V. Lamb, New Castle, PA, 1987.

Zona, Beverly. *All the Summers Were Golden: A History of Cascade Park.* New Castle, PA: Lawrence County Historical Society. 2001.